THE FLICK

BOOKS BY ANNIE BAKER
PUBLISHED BY TCG

The Flick

Uncle Vanya
By Anton Chekhov
Adaptation by Annie Baker

The Vermont Plays
INCLUDES:
The Aliens
Body Awareness
Circle Mirror Transformation
Nocturama

THE FLICK

Annie Baker

THEATRE COMMUNICATIONS GROUP NEW YORK 2014

The Flick is published by Theatre Communications Group, Inc., 520 8th Avenue, 24th Floor, New York, NY 10018-4156

The publication of *The Flick* by Annie Baker, through TCG's Book Program, is made possible in part by the New York State Council on the Arts with the support of Governor Andrew Cuomo and the New York State Legislature.

Special thanks to Judith O. Rubin for her generous support of this publication.

The excerpt from *Pulp Fiction*, screenplay by Quentin Tarantino, was originally published in the U.S. by Miramax Books, Hyperion, New York, 1994.

TCG books are exclusively distributed to the book trade by Consortium Book Sales and Distribution.

LIBRARY OF CONGRESS CATALOGING-IN-PUBLICATION DATA
Baker, Annie, 1981–
The Flick / Annie Baker.
pages cm
ISBN 978-1-55936-458-4 (paperback)
ISBN 978-1-55936-487-4 (trade cloth)
I. Title.
PS3602.A5842F58 2014
812'.6—dc23 2014019211

Book design and composition by Lisa Govan
Cover design by Rodrigo Corral Design/Rachel Adam Rogers

First Edition, August 2014
Seventh Printing, February 2021

THE FLICK

PRODUCTION HISTORY

The Flick was commissioned by and received its world premiere at Playwrights Horizons (Tim Sanford, Artistic Director; Leslie Marcus, Managing Director; Carol Fishman, General Manager) in New York City on March 12, 2013. It was directed by Sam Gold; the set and costume design were by David Zinn, the lighting design was by Jane Cox and the sound design was by Bray Poor; the production stage manager was Alaina Taylor. The cast was:

SAM	Matthew Maher
AVERY	Aaron Clifton Moten
ROSE	Louisa Krause
SKYLAR/THE DREAMING MAN	Alex Hanna

THE SETTING

A falling-apart movie theater in Worcester County, MA. The set is the raked movie theater audience, ten to fifteen rows of red seats with a dingy carpeted aisle running up the center. The upstage wall is the back wall of the movie theater, with a window into the projection booth. There is a metal door leading out into a hallway which leads out into the movie theater lobby. We, the theater audience, are the movie screen. The beam of light from the projector radiates out over our heads.

Summer 2012.

THE CHARACTERS

SAM, thirty-five
Shaved head. Caucasian.
He often wears a beat-up Red Sox cap.
He used to be very into Heavy Metal.

AVERY, twenty
African-American. Bespectacled.
He wears red slightly European-looking sneakers.
In love with the movies.

ROSE, twenty-four
Caucasian. Sexually magnetic, despite the fact that (or partly because?) her clothes are baggy, she never wears makeup and her hair is dyed forest-green.

SKYLAR/THE DREAMING MAN, twenty-six

NOTE ON COSTUMES

Sam and Avery wear the same degrading movie theater uniform in every scene. It is a polo shirt (probably dark blue or purple or maroon) with a little name tag/pin and black pants. Maybe the polo has "The Flick" embroidered in yellow or white on its chest pocket. Because Rose is the projectionist she doesn't have to wear a uniform. But maybe she wears the black pants anyway. Or the same pair of jeans every day.

" / " indicates where the next line of dialogue begins.

PRE-SHOW

After the theater audience has filed in, the house lights slowly dim (onstage in the movie audience and also in the theater audience).

Bernard Herrmann's Prelude to The Naked and the Dead *starts playing, and the light from the projector beams out over our heads. Images that we cannot decipher are being projected. Dust motes are illuminated by the light.*

This lasts two minutes (from beginning to end of the song) and all we can see are abstracted dancing images shooting out of the film projector.

Then the song ends, and the unknown movie ends, and there is a bright flash of green, and then white. The movie theater lights automatically flicker on, and after about five seconds . . .

ACT ONE

SCENE ONE

The door at the back of the movie theater is thrown open.
Sam peeks his head in, looks around, and then closes the door.
A second later, the door opens again and Sam drags in a large trash
can that he uses to keep the door propped open. Then he exits again
and reenters carrying a push broom and dust pan. Avery follows him
in, carrying a push broom and dust pan of his own.

SAM

We call this the walkthrough.

Pause.

SAM

Pretty simple.
You just ah . . .

Avery watches as Sam walks down the last row of seats with his broom, sweeping up popcorn kernels, etc., and pushing them into the dust pan. When Sam finishes the last row and moves to the second-to-last row, Avery awkwardly begins sweeping the last row on his side of the aisle. They continue this way, Sam always one row ahead of Avery, each on his own side of the aisle. Avery is trying to figure out the best way to sweep; it's harder than it looks. In the third-to-last row, Avery encounters something we cannot see on the floor. He frowns with distaste, then bends over and gingerly picks up a Subway sandwich wrapper. Tiny pieces of shredded lettuce flutter to the ground.

Sam looks over, stops what he's doing, and watches Avery, without offering any suggestions.

Avery walks up the aisle, throws the Subway wrapper in the large trash can, along with the contents of his dust pan, then walks back and goes back to sweeping. For some reason it's not working—the tiny pieces of lettuce that we can't see are sticking to the ground. Sam is still watching him. After a while:

SAM

Yeah. With the little pieces of lettuce you kind of have to—

Avery interrupts him by bending down to hand-pick the pieces of lettuce off the floor. He mostly disappears from view.

Sam watches, then goes back to sweeping. He's about three rows ahead of Avery when Avery finishes picking up the tiny pieces of lettuce. Cradling them in his palm, Avery walks up the aisle again to the trash can and shakes his palm off into it. Then he goes back to sweeping. After moving on to the next aisle:

AVERY

What do you do about spilled soda?

SAM

We do one big mop at the end of the night.

Avery nods. They go back to sweeping. After about twenty seconds:

AVERY

What if people are still here?

A pause.

SAM

Like—

AVERY

Have you ever had anyone like just sit here and refuse / to—

SAM

Sometimes people stay until the end of the credits. But then they go.

Avery nods.

SAM

And they'll get the message when you start sweeping.

Avery goes back to sweeping. After a pause:

SAM

Roberto told me that he once . . . that one time this couple was like having sex, like fully fucking on the seats when he came in.

AVERY

Whoa.

SAM

But he just like ignored them and like went about his business.

They continue sweeping. After a pause:

AVERY

Who's Roberto?

SAM

Oh. He doesn't work here anymore.

Pause.

SAM

He joined the Marines.

Pause.

AVERY

And who was the guy with the / big—

SAM

That was Brian.
Sundays and Mondays is Brian and Rebecca.
But you'll never meet them because you'll never work Sundays and Mondays.

Avery nods, a little uncomfortable. They go back to sweeping. They're almost done. Sam is in the second row and Avery is in the fourth row. When Sam finishes he just watches Avery.

SAM

Did Steve tell you about the soda machines?

AVERY

Uh . . . like . . .

SAM

How to clean them? About the seltzer?

AVERY

... No ...

SAM

You gotta soak the spouts in seltzer overnight.

AVERY

Oh. Okay. Cool.

SAM

I'll show you.
In a minute.

About ten more seconds, then Avery finishes sweeping. They head up the aisle together and dump their dust pans in the trash can. Then Sam takes the trash can and starts rolling it out the door. They are almost out the door when Sam says:

SAM

So you're into movies?

AVERY

What? I mean yeah! I love movies.

And they're gone. The door swings shut behind them. Blackout.

SCENE TWO

Sam, alone in the middle of the theater, sweeping. After a few seconds, Avery runs in, fastening his little name tag pin and holding his broom.

AVERY

Hey!

SAM

Hi Avery.

Pause.

AVERY

Sorry / I'm—

SAM

You're late.

AVERY

Yeah. I was just about to . . . yeah. I'm really sorry.

SAM

Yeah. Uh-huh. I / just—

AVERY

My dad was supposed to give me a ride but then he couldn't and I had to take like three different buses to get here and I'm still trying to figure / out the whole—

SAM

Uh-huh, yeah, I don't really need an explana/tion, it's just—

AVERY

No, no, of course, I just feel bad and I can totally reassure you that it won't happen again.

Pause.

SAM

It just puts me in an awkward position because / I'm—

AVERY

The thing is, I'm actually like . . . I'm actually like this obsessively punctual person and I'm like never ever late and this was just like a crazy um anomaly with the buses and now I know and I can promise you it will never happen again.

Pause.

SAM

Fine. Fine.

Pause. Sam goes back to sweeping, then:

15

SAM

I mean, it's no big deal.

But I'm sort of de facto in charge on Saturdays / and—

AVERY

No, I know.

SAM

It just puts me in an awkward position. That's all. Steve's never here so it was just me and I / had to—

AVERY

I can promise you that it won't happen again.

Pause.

SAM

I had to do soda and make a whole batch of popcorn by / myself.

AVERY

I'm so sorry.

SAM

No. It's cool.

Pause. They both start sweeping. Then, unable to help himself:

SAM

I'm just like—I don't know why Steve doesn't fucking promote me. I'm so sick of this shit.

Avery nods, a little confused.

SAM

I should be a fucking projectionist by now!

AVERY

Oh. Yeah. I'd love to do that.

SAM

Well, he'll probably promote you before he promotes me. He like clearly thinks I'm *diseased* or something.

Pause.

SAM

He promoted Rose and I've worked here five months longer than her.

They go back to sweeping.

SAM
(*looking down at the floor in his row*)
Aw fuck.
What is this.

Avery stops and peers over from his side of the aisle.

SAM

Someone spilled like chocolate pudding or something. Are you fucking kidding me?

AVERY

Are you sure it's not, like . . . shit?

A pause. Sam bends down and inspects it.

AVERY

Oh god.

SAM

. . . Definitely not shit.

AVERY

Are you sure?

SAM

Uh-huh.

AVERY

Because I'm kind of um . . . I'm kind of shit-phobic.

SAM

There are like weird little *balls* in it.
It's like *chocolate tapioca pudding.*
Who brings pudding into a movie theater?!

Sam gazes at it for a while, then straightens up, steps around it, and goes back to sweeping. Sam notices Avery watching him and gets a little self-conscious.

SAM

. . . I'll take care of it later.

They sweep for a while. Then:

SAM

What does that mean, shit-phobic?

AVERY

Like other people's shit makes me . . . it like makes me want to puke.

SAM

Well sure.

> AVERY

Yeah. But with me it's really . . . like if I go into the stall and someone has, um, like if someone's left something there I actually sometimes like . . . I actually need to puke. Like sometimes I actually puke.

> SAM

Huh.

Pause.

> SAM

Have you heard of that website where people send in pictures of their shit and then other people rate it?

> AVERY

Yes I have heard of that website. That website is like my worst nightmare.

Sam giggles.

> SAM

So if I wanted to be really like cruel I could like leave my laptop open with that website up and you / would—

> AVERY

I would literally puke all over your laptop.

Sam giggles.

> SAM

Oh man.

A happy pause in which they realize they've broken the tension, and then awkward pause following that happy pause. They go back to

sweeping. A minute later, someone appears in the window of the projection booth. It is a girl. She is moving around, changing reels, appearing in and out of view.
Sam notices her.

SAM

Oh. Hey. That's Rose.

Avery looks up.

SAM

HEY ROSE!

She doesn't hear him. After a little while:

SAM

Huh.
I guess she like hates me or something.
ROSE!
　(pause)
ROSE!!
Wow.
She really hates me.

AVERY

Maybe she can't hear you.

SAM

She can hear me.
Rose!
I want to introduce you to her. She's cool.
ROSE!!

Rose continues moving around in the projection booth, oblivious.

20

<center>SAM</center>

(a cry of pure agony/unrequited love)
ROOOOSSSSSE!!!!!!!

Rose remains oblivious.

<center>SAM</center>

Well.
She officially hates me.

Sam and Avery gaze up at the projection booth while Rose moves around, then disappears from view. Avery goes back to sweeping. Sam keeps watching the window as if he hopes she might appear again. This goes on for about ten seconds, then:
Blackout.

SCENE THREE

A few days later. Sam and Avery are in the middle of sweeping on their separate sides of the aisle.

SAM

Jack Nicholson.
Jack Nicholson and uh . . .
And uh . . .
Renée—no.
Dakota Fanning.
Jack Nicholson and Dakota Fanning.

A short pause.

AVERY

That's too easy.

SAM

Well just do it then.

AVERY

. . . Jack Nicholson to Tom Cruise in A Few Good Men. Tom Cruise to Dakota Fanning in War of the Worlds.

SAM

Huh.

AVERY

Come up with a better one.

SAM

Fine. Fine.
Uh . . .
Pauly Shore.
Pauly Shore and uh . . .
Ian Holm.

AVERY

Okay.

Avery thinks. He squints and raises his index finger slightly, as if drawing complicated algebraic equations in the air. After about six seconds . . .

AVERY

Pauly Shore to Stephen Baldwin in Bio-Dome.

SAM

You have it already?

AVERY

Stephen Baldwin to Kevin Pollak in The Usual Suspects.
Uh . . . uh . . . Kevin Pollak to Bruce Willis in . . . uh . . . let's
say . . . The Whole Nine Yards.

SAM

What do you mean "let's say"?

AVERY

They were also in The Whole Ten Yards together and—I think—Hostage.
And then Bruce Willis to Ian Holm in The Fifth Element.

SAM

Jesus.

AVERY

Make it harder.

SAM

Uh . . . uh . . . uh . . .
Uh . . .
Michael J. Fox! Michael J. Fox and uh . . .
Ooh. Okay.
Michael J. Fox and Britney Spears.

Avery nods.

AVERY

Okay.

He closes his eyes. About ten seconds pass.

SAM

Ooh-hooh. This one is hard.

Avery's mouth moves slightly and his eyes do strange things while he does his calculations.

SAM

This is a doozy.

Avery's eyebrows raise—it seems like he is getting somewhere—but then he clearly reaches a roadblock.

SAM

Ooooo boy.
Uh-oh.

About twenty more seconds of silent calculations. Eventually Avery unties some kind of complicated mental knot, opens his eyes, and grins.

SAM

No.
NO!

AVERY

This one takes a full six degrees but I'm happy with it.
 (pause)
Britney to Kim Cattrall in Crossroads.

SAM

Okay.

AVERY

Kim Cattrall to Estelle Getty in Mannequin.

SAM

Mannequin!
My first sexual fantasy EVER was about Kim Cattrall in Mannequin!

AVERY

I've actually never seen it.

SAM

It's the best. It's the best. Cattrall is this mannequin who comes to life and Andrew McCarthy is the department store worker window guy who falls in love with her. And Estelle Getty is the store manager.

I don't remember *why* exactly Kim Cattrall comes to life. There's some sort of magic Egyptian-y reason behind it. And then she / like—

AVERY

Estelle Getty to Sylvester Stallone in Stop or My Mom Will Shoot.

Sylvester Stallone to John Lithgow in Cliffhanger.

Lithgow to Christopher Lloyd in . . . uh . . . okay . . . I'm pretty sure this is the title: Adventures of Buckaroo Bansai Across the Eighth Dim/ension.

SAM

WHOA!!

WHAT THE FUCK!!!

YES!!

I LOVE THAT MOVIE!

AVERY

Christopher Lloyd to Michael J. Fox in, of course . . .

SAM	AVERY
Back to the Future.	Back to the Future.
Parts One through Three.	

A pause. Sam stares at Avery, in awe. They don't notice Rose enter the projection booth.

SAM

You have like a . . . that's like almost like a *disability*.

> AVERY

It's actually like the opposite of a disability.

Rose knocks on the window of the projection booth and waves at them.

> SAM

Oh! Jesus!
 (to Avery)
That's Rose.

> AVERY

I know.

They wave back. Rose breathes on the window, making a little foggy area, and then draws a cartoon penis in the fog with her finger. It may or may not be decipherable.

> AVERY

What is that.

> SAM

. . . I *think* it's a penis.

Rose draws a heart around the penis.

> AVERY

Whoa.

> SAM

Yeah.
She's a lesbian.

> AVERY

Really?

SAM

Yep.

Rose is un-threading the projector now, mostly obscured from view.

AVERY

Does she have a girlfriend?

SAM

Shhh. Uh. No. I don't think so.

They go back to sweeping. They don't see Rose leave the projection booth. They keep sweeping. Rose appears in the doorway. She regards Sam and Avery, then:

ROSE

Hi. I'm Rose.

AVERY ROSE

I'm Avery. Avery, right?

AVERY

Yeah.

Pause.

ROSE

How old are you?

AVERY

Twenty.

ROSE

Huh.

Pause.

> ROSE

I like your shoes.

Avery looks down at his shoes.

> ROSE

Red.

Pause.

> AVERY

. . . Thanks.

Another pause.

> ROSE

Hi Sam.

> SAM

Hello Rose.

Pause.

> ROSE

I'm really hungover so you guys will have to excuse me if I'm like a little low-energy tonight.

Avery goes back to cleaning. Rose leans sleepily against the wall. Sam seems eager to talk to her.

> SAM

Who were you out with?

ROSE

(fake-spaced-out)
What?

SAM

Oh. Uh. Who were you partying with last night?

ROSE

Just a couple of friends.

SAM

Katie?

ROSE

Oh my god. Katie is like . . . no.
Reiko. And this other guy.
We all drank moonshine . . . have you guys ever had moon-
shine?

SAM	AVERY
Uh-huh.	No.

ROSE

Anyway. I'm just like . . . I totally have a drinking problem.

She fake yawns. Avery accidentally drops his broom, then quickly picks it up.

ROSE

I'm gonna go take a nap. When does the next show start?

SAM

6:20.
Do you need anything? I could like run out and get you some-
thing.

ROSE

Oh my god no. I'm totally fine.

She starts to leave, then stops.

ROSE

It was nice meeting you Avery.

AVERY

Yeah. You too.

ROSE

Those shoes rock.

Rose exits. Sam stands there. Avery continues sweeping. After a safe amount of time has gone by:

SAM

. . . So?

AVERY

What?

SAM

What'd you think?

AVERY

She was—

Rose reenters.

ROSE

(to Sam)
Did you tell him about Dinner Money?

Sam gets weird.

SAM

Uh—what? No. Wait—

ROSE

What did you do last night?
Did you take it all?

SAM

I thought that—he just started working here, / so—

ROSE

Well. Exactly, dumbass. You have to explain it to him.

SAM

It's just—we have no idea if he's going to be cool with / it and—

ROSE

He *has* to be cool with it.

Avery is trying to look like he's not listening.

SAM

Hey. Avery.

Avery turns around.

AVERY

Yeah.

SAM

At the end of every shift you're gonna get Dinner Money. It's just a little extra cash. We always split it three ways or two

ways if there's just two of us. It can be anywhere from you know ten bucks on a weeknight to like thirty bucks on the weekend.

AVERY

Oh. Cool.

Short pause.

ROSE
 (*to Sam*) AVERY
See? It's fine. So it's like a per diem?

ROSE

A what?

SAM

No. Uh. Well. Kind of. It's kind of like a per diem. It's just . . . Steve doesn't know about it.

A weird pause.

AVERY

Steve doesn't give it to us?

Rose looks at Sam. Sam struggles to find the right way to say it.

SAM

When we . . . when we take the tickets, we just kind of . . . you know when you tear them in half and put the other half in the / bin, well—

AVERY

Yeah. Sure.

SAM

Well, sometimes we take like, uh, like ten percent of those stubs, and we, uh, we, uh, we, uh, resell them.

A pause.

SAM

And then we take ten percent of the, uh, the, uh . . .
Cash for the night.

ROSE

As Dinner Money.

SAM

We call it Dinner Money.

ROSE

Well, it *is* kind of dinner money, because we're so vastly underpaid and because Steve is a total douchebag and doesn't have a credit card machine and is like totally fishy anyway with his finances and basically has like no idea how to run a movie theater.

A pause.

ROSE

So actually it like, it *is* dinner money.
Because $8.25 an hour is *not* enough to live on.

AVERY

You've never been caught?

ROSE

No, it's like a like a like an employee tradition? Roberto—the guy who trained me—he told me about it and the people who

worked here before him told *him* about it and like nobody has
ever been caught or like even been close to being caught.
Because Steve is just like . . . he's an idiot.
He can like suck my cock.

Avery looks at Sam. Sam is embarrassed.

AVERY

Uh . . . so what are you guys asking me?

ROSE	AVERY
I guess we're not asking you anything.	Because I don't really want to do it.

ROSE	SAM
But you can't . . . it's not up to you to decide!	You don't have to do anything! I'll deal with the tickets! You just get half the money!

AVERY

I don't want to take Steve's money.

ROSE

Okay, see, I don't think of it as Steve's money. Steve is like
a compulsive gambler who doesn't pay child support. He
has like five kids somewhere in like Maine and his ex-wife is
always taking him to court.

A long pause.

AVERY

I don't want the money. I'm not gonna like rat you guys out
but, no, I'm sorry, I could tell he didn't really want to hire a
black guy anyway and / I'm not gonna—

35

SAM

WHOA! Really?! Steve is a racist?!!

AVERY

I don't know, okay? That's / what I'm—

ROSE

That's so lame. That's so lame. He's such a fucking racist.

AVERY

I'm not saying . . . I'm just . . . he's like an older angry white dude with a truck and like . . . it's just one of those things . . . where like if something goes wrong . . .

A very long, uncomfortable pause.

ROSE

I don't feel that way.

Pause.

AVERY

Wait, what?

Another weird pause.

SAM

Can I just say . . . I guess I just want to say that, uh, Roberto . . . Roberto was Hispa—Latino?
And uh nothing ever happened.
Nothing bad ever happened to him.

Silence. Avery walks down the aisle, sits in the front row, and puts his head in his hands. They watch him.
After a second, he takes off his glasses, wipes them off on his polo shirt, puts them back on, and then puts his head in his hands again.

Sam and Rose watch him do this, and then start mouthing panicky silent things to each other. Maybe Rose is mouthing stuff like WHAT DO WE DO??!! HE'S GONNA TELL ON US!! and Sam is mouthing stuff like IT'S COOL IT'S COOL I'LL TALK TO HIM IT'S GONNA BE COOL but we shouldn't really be able to read their lips and maybe they can't either; it's more just like mutual gestures of panic. Then they go back to watching Avery, who is unmoving in his seat.

SAM

If you have like—
If it's like an ethical you know—
You could always uh . . .

He trails off. Another silence.

ROSE

Listen.
Avery.
I don't want to be like a total cunt about this and I don't want to put you in a crappy position.
But if me and Sam are doing it and you're not it's like . . . it's like not fair to anybody. Like it's like really bad for everyone involved.

A few seconds later, Avery stands up, shakes his head as if to clear it, and puts his hands on his hips.

AVERY

Yeah.
Okay.
Fine.

Pause.

ROSE

Wait, what does / that—

<center>AVERY</center>

It's fine.
I'll take—I'll do whatever.
It's cool.
Sorry.
I didn't mean to like . . .
I didn't mean to freak you guys out.
Or be judgmental.
 (pause)
Sorry. Yeah.
I'm okay with it.

They stare at him.
He laughs nervously.

<center>AVERY</center>

Seriously!!
I'm fine.
Sorry.

Rose and Sam exchange a long look. Then:

<center>ROSE</center>

. . . All right, boys.
I'm gonna go take a nap in the booth.
Wake me up at five till.

She leaves. Sam looks at Avery. Avery finally stands up. They resume sweeping. After a little while:

<center>SAM</center>

Richard Pryor and Angelina Jolie.

Blackout.

SCENE FOUR

Sam and Avery are in the middle of sweeping. Avery is whistling to himself ("Le Tourbillon" from Jules and Jim*). After about a minute:*

SAM

You know what I hate the most?

Avery stops whistling.

SAM

It's one thing if I sold you the food. It's one thing if you
you know legitimately purchased the food from me and then
leave it like scattered across the floor.
But to SNEAK FOOD IN . . .
To sneak outside food in and THEN to like scatter it across
the floor and leave empty bags of . . .
 (he lifts up the bag)
. . . Sun Chips on your seat.
That I do not understand.

AVERY

I feel the opposite.

SAM

What do you mean?

AVERY

It feels so weird when I sold it to them. It's like, I gave you that popcorn. I like scooped it out myself and put it in the bag and handed it to you and you paid me and said thank you. And now it's all over the floor.

SAM

Huh.

AVERY

With the Sun Chips it's like . . . it's just regular litter.

SAM

Interesting.
Interesting perspective.

They continue sweeping. Avery resumes his whistling. After a while:

SAM

(*incredulous*)
Someone left a shoe.

He lifts a shoe up in the air disdainfully.

SAM

Someone left a nasty nasty old New Balance shoe.

AVERY

Do you think it was intentional?

SAM

Like is it a sign of gang *warfare* or something?

AVERY

No. Like do you think someone forgot it and left here with
one shoe on . . .
Or do you think they like meant to throw it away?
 (a short pause)
Like do we put it in the lost and found?

SAM

Fuck no.
Fuck no.
It smells disgusting.

Sam walks up the aisle to the trash can, holding the shoe by its lace.

SAM

Uch. Uch. Uch. Uch.
UchUchUchUchUchUchUch.

He throws the shoe in the trash.
Then Sam reaches under his polo shirt and scratches his collarbone.

SAM

My *neck* itches.

They continue sweeping. After about twenty seconds:

AVERY

Hey.
What do you wanna, like . . .
What do you wanna like be when you grow up?

Pause.

41

SAM

. . . I am grown up.

AVERY

Oh.
Yeah. I guess I just mean / like—

SAM

That's like the most depressing thing anyone's ever said to me.

AVERY

Sorry.

They finish sweeping. They empty their dust pans into the trash. On their way out the door:

SAM

A chef.

Blackout.

SCENE FIVE

Darkness. The final credits of a movie. Swelling music. Light from the projector.
A Dreaming Man has stayed till the end of the credits.
The music ends. A flash of green. A flash of white. The lights in the theater automatically flicker on.
A few seconds later, Avery and Sam come in through the door, in the middle of a conversation. This time they have mops and a large yellow mop bucket on wheels. It is the end of the night.

SAM
(not noticing there is still someone in the theater)
I disagree.
I *strongly* disagree.

AVERY
Name one. Name one great American movie made in the—

Avery notices the Dreaming Man and stops talking.
The man is in the fifth or sixth row, lightly sleeping, facing forward.
Maybe his head is subtly listing to one side.
Sam and Avery start to clean, waiting for him to go. The man is
on Avery's side of the aisle. Avery eventually walks over, looks at the
man, and sees that he's asleep. Avery isn't sure what to do. He ges-
tures for Sam to come over. Sam comes over.

AVERY

(to the man)
Excuse me.

The man doesn't move or wake up.
Sam pokes his shoulder, a little too aggressively.
The man jolts awake and stares at them.

SAM

The movie is over.

THE DREAMING MAN

Oh. Sorry.

Sam walks back to his side of the theater and resumes cleaning.
Avery remains standing in the aisle, holding his mop, unsure of
what to do. The man wipes the sleep from his eyes, maybe searches
for something on the floor, gathers his things, and then departs, not
making eye contact. He walks up the aisle, head bowed, and out the
door. It slams behind him.
A pause, then:

SAM

Avatar! Avatar was a great movie made in the last ten years.

AVERY

I . . . what?!

More incredulous pausing.

<center>AVERY</center>

Okay. Uh. If you think that, if you actually think that, I can't even like . . . I can't even like continue to have this conversation. If you actually think that I need to like quit this job.

<center>SAM</center>

Avatar was a great movie.

Pause.

<center>SAM</center>

Avatar was a work of genius!

<center>AVERY</center>

I can't even . . . I can't even . . .
Words are failing me.

<center>SAM</center>

Oh so like oh so you think you're like *better* than Avatar. Like you're above Avatar.

<center>AVERY</center>

No. I / just—

<center>SAM</center>

Because I bet you really fucking enjoyed Avatar. I bet you had a blast at Avatar. And now you're like looking down your nose at Avatar because it didn't have like German subtitles or whatever.

<center>AVERY</center>

I repeat: I don't think it's possible for me to engage in like a rational debate with you about it.

<center>45</center>

SAM

Oh come on.

AVERY

It's like if I said: I love killing babies. Let me like try to convince you why killing babies is fun and you should enjoy killing babies.

They go back to mopping. Unnoticed by them, Rose appears in the projection booth, cleaning up, removing the film.
Silence for a while, then finally, unable to help himself:

AVERY

It was a video game.

SAM

Excuse me?

AVERY

Avatar was basically like a video game.

SAM

It was not a video game.
A video game is interactive.
A video game is defined by the fact that you're . . . that you're . . .
 (moving on)
It was 3-D. That was fucking awesome. Did you see it in 3-D?

AVERY

Uh-huh.

SAM

It's just like different and that like scares you. People always freak out when like you know when like art forms move forward.

> AVERY

That's not the art form moving forward. That's the art form moving backwards. 3-D was around in like the '50s.

Rose leaves the projection booth.

> SAM

I thought it was totally awesome-looking.

> AVERY

I don't like digital.

> SAM

It's where film is going.

> AVERY

Well then it won't be film anymore.

Rose enters, holding a book.

> ROSE

Hey. Look what I found on the street.

Sam walks over to her and reads the title out loud:

> SAM

"Astrology and Your Love Life: How to Find True Compatibility and Long-Lasting Relationships."

> ROSE

What's your sign?

> SAM

Uh . . . Leo.

ROSE

Oh my god me too.

Rose flips through the book.

ROSE

What about you, Avery?

After a short pause:

AVERY

I don't know.

ROSE

Excuse me?

AVERY

I don't remember.
I don't really care about that kind of thing.

ROSE

Oh my god. Oh my god.
You are so full of shit!

AVERY

I don't believe in astrology.

ROSE

Okay, that's fine, but you know what your sign is. I don't buy
for a second that you don't know what your sign is.

Pause.

ROSE

Oh my god Avery!
Don't even try to *pretend* with me that you don't know what /
your—

AVERY

Capricorn.

ROSE

. . . Thank you.

She flips through the book again.

SAM

Hey Rose.

ROSE

(still looking through the book)
Ye-es . . .

SAM

Avery thinks there hasn't been a single great movie made in
the past ten years.

AVERY

Single great *American* movie.

ROSE

(still flipping)
Uh-huh.

SAM

And I think he's wrong.

AVERY

(to Sam)

Pulp Fiction was the last *truly* great American movie and that was '94.

SAM

You have to do some of it for Rose.

AVERY

No.

ROSE

Do what?

SAM

He has like all of Pulp Fiction memorized and he can / like—

AVERY

Nope.

SAM

Do Ezekiel 25:17!

AVERY

No way.

SAM

(to Rose)

He does the most like incredible Samuel L. Jackson imitation.
(in a bordering-on-offensive voice)
"THE PATH OF THE RIGHTEOUS BROTHER IS BESET ON ALL SIDES BY THE TYRANNY OF THE WEAK"!

Rose eyes Avery dubiously.

 AVERY

That's not how it goes.

A pause.

 ROSE

What about Million Dollar Baby?

 AVERY

What about it.

 ROSE

That's a great movie.

 AVERY

That is not a great movie.

 SAM

Avery is like a film snob.

 ROSE

Tree of Life?

A grim silence. Sam shakes his head, embarrassed.

 ROSE

Oh boy. You both hate Tree of Life.
Okay.
Sam and Avery, I'm gonna read you your compatibility.
It's me and Avery's compatibility too because I'm also a Leo.

 SAM

Magnolia!
There Will Be Blood.

AVERY

Those are good movies. Very good movies.
But ultimately disappointing.

SAM

Lord of the Rings! Return of the King!

AVERY

Are you kidding me?

SAM

Uh uh uh uh . . .
The third Bourne movie!
The Bourne Ultimatum!

AVERY

This is a pointless debate.

SAM

Oh come on!
Those Bourne movies are like like like fine wines!

Avery shakes his head.

SAM

Uh . . . The Aviator! Wait. Never mind.

ROSE

(reading loudly)
"Leo and Capricorn."
"It's hard to make this combination of personalities work in a
long-term love relationship."
Ooh. Sorry guys.

SAM

(rolling his eyes)
Ha ha.

ROSE

"Orderly and organized, Capricorn is likely to disapprove of Leo's exuberance and spontaneity. Leo has a bad temper but is quick to forgive and forget; Capricorn is more even-tempered but can hold a grudge for years. Capricorn is also the more devoted partner and Leos tend to have a wandering eye. Most of all, Capricorn and Leo are not sexually compatible. They are both dominators and yet almost complete opposites. Prudent practical Capricorn is often a bit of a snob and fairly / conservative—"

SAM

OH MY GOD! I JUST SAID HE WAS A SNOB!
AVERY I JUST CALLED YOU A SNOB!

AVERY

Uh-huh.

ROSE

". . . often a bit of a snob and fairly conservative, and will probably try to tamp down Leo's adventurous and impetuous personality."
Uh . . . what else . . . blah blah blah . . .
"Capricorn is an Earth sign and Leo is a Fire sign . . . it can take Capricorn a while to open up his/her heart but once Capricorn opens it he/she is extremely loyal . . . but it will be very hard to make this marriage work . . ."
Ooh!
Wait. There's a "Business and Career section"!

AVERY

That's probably more relevant.

ROSE

"Business and Career."

Hey!

"The career connection between Leo and Capricorn is fantastic"!

"They are both excited to learn from one another. Usually one partner has more experience and will *show the other the ropes.*"

She looks up and grins.

SAM

. . . Whoa.

That's weird.

That's . . . Actually Weird.

ROSE

"As long as there is not a power struggle there can be an incredible and fruitful collaboration."

Uh . . .

"Connections with the arts are favored"!

SAM

No!!

He looks over her shoulder.

SAM

(to *Avery*)

It actually says that!!

ROSE

(*shutting the book*)

That is awesome, you guys.

Sam stands there, stunned.

> SAM

So weird.
So weird.
> (*pause*)
I mean I don't believe in that stuff but that is SO WEIRD.

Avery goes back to mopping.

> SAM

You don't think that's weird??!!

> ROSE

He's just being a typical Capricorn.

> SAM

Ha ha! Yes! Prudent and practical!

Avery cracks a smile.

> SAM
> (*to Rose, summoning up the courage*)

What about us?

> ROSE

What about us?

> SAM

Leo on Leo.
I mean, Leo with Leo.

> ROSE

Oh.

She flips through the book nonchalantly.

ROSE

Hmmm . . . I think the same sign together is usually a bad
thing . . . let's see . . .

"Leo and Leo."

"When this relationship is good it is very good, but when it
is bad it is terrible. Leos have a very strong sex drive, so this
couple will be highly compatible in bed. This is a kinky, pas-
sionate connection, but can sometimes be hard to sustain in
a long-term way. These two Leos are King and Queen of the
jungle. It will either be a great love or a great rivalry. The big
question is: who's the boss? There will be heartfelt embraces
but also egos butting heads. Compromise is key in the fiery
relationship between two Leos."

Pause. Sam is blushing.

SAM

(trying to sound unimpressed)
Huh.

Rose closes the book.

ROSE

I wonder what sign Reiko is.

SAM

What's our career connection?

ROSE

Yeah. I'm bored.

She gets up.

ROSE

(to Avery)
See ya later, Capricorn.

AVERY

Uh-huh.

She leaves.

SAM

Wes Anderson.
Rushmore.

AVERY

That was '98.
And that is a good movie, but not a Pulp Fiction–level good movie.

They mop for a while.

SAM

I think he has a new one coming out this winter.
 (short pause)
Tarantino.

AVERY

Django Unchained.

SAM

What?

AVERY

It's called Django Unchained.

More mopping.

SAM

The Coen Brothers!
All the Coen Brothers movies.
No Country for Old Men.
A Single . . . what's it called.

AVERY

A Serious Man.

SAM

Fargo!! Fargo.

AVERY

First of all, Fargo was '96.
Second of all, those are all pretty good movies. Those are *interesting* movies.
But those are not like like like like . . . profound commentaries on / like—

SAM

Do you find Rose attractive?

Pause.

AVERY

Wait—do I find—
Rose?

SAM

Yes. Rose.
I feel like you guys have kind of a flirty antagonistic banter thing going on.

AVERY

I mean uh—I don't know. No. Not really.

SAM

Not *really*?

AVERY

No. I mean no.
She's . . . she kind of makes me uncomfortable.

SAM

. . . Huh.

AVERY

She's a lesbian anyway, so / it—

SAM

Yeah.
Yeah.

AVERY

Do *you* find Rose / attr—

SAM

Shhhhhhh.

They clean for a while.

SAM

Hey. Will you come over here and look at my neck?

Avery puts down his mop and walks over to Sam.

SAM

Does it look weird?

AVERY

Well there are all these red blotches but I can't tell if that's
because you've been scratching it.

SAM

What about my back.
My back itches too.

Sam turns around and lifts up the bottom of his shirt.

AVERY

Oh. Yeah.

SAM

Yeah what?

AVERY

Yeah. There are a bunch of red like . . .
They're like little red lesions or something.

SAM

Lesions??

AVERY

Like they're kind of red oval-shaped . . .
Auggh!

Avery pulls Sam's shirt down.

SAM

What? What?

AVERY

They started freaking me out.

SAM

Great.
Fucking great.
I'm gonna go look in the bathroom.

Sam exits. Avery keeps mopping, by himself. He reaches the front row. Rose knocks on the window of the projection booth. Avery looks up. Rose smiles and mouths something he (and we) can't understand.

<div style="text-align:center">AVERY</div>

What?

She mouths it again.

<div style="text-align:center">AVERY</div>

Wait, what?

She flaps her hand in the air, as if to say "forget about it," and then goes back to de-threading the projector. Avery continues mopping. Sam walks back in.

<div style="text-align:center">SAM</div>

Weird.
Some of them are like *scaly.*
What the fuck.

<div style="text-align:center">AVERY</div>

Have you ever had chicken pox?

<div style="text-align:center">SAM</div>

Yeah. Twice.
When I was a kid.
It's definitely not chicken pox.

A pause.

<div style="text-align:center">SAM</div>

. . . Repulsive.

Avery doesn't really know how to respond to this so he finishes mopping his side and then moves on to Sam's side and keeps mopping. Sam just stands there.
Blackout.

SCENE SIX

Avery, alone in the theater, squatting on the back of one of the seats, talking to his therapist on his cell phone.

AVERY

Yeah.

And that—

Yep.

 (pause)

Yeah.

 (pause)

Yeah.

Well.

How do you like *do* that? How do you like ask someone to be friends with—

A long pause.

AVERY

Uh-huh.

And . . .

Yeah.

Well that makes me feel insecure too.

Pause.

AVERY

Oh!

I finally remembered one of my dreams.

 (pause)

Yeah.

 (smiling)

I *thought* you'd be happy about that.

 (pause, glancing at the door)

We're on a break.

Everyone went to Subway.

 (pause)

Okay. So in the dream I'm dead. I mean, I've just died. And I'm in this weird room. Which is basically like purgatory. And there's a whole bunch of us, a bunch of people who just died, and we're all waiting to see if we can, you know, move on. To the next level. Oh. And my dad is there. Because he just died too. And then the room suddenly turns into my dad's study. And this person starts scanning all the books on my dad's bookshelves with this ISBN-type scanner thing and they run the scanner over all of his books and eventually one of the books goes like BEEP BEEP BEEP and the scanner recognizes it and that means my dad is going on to heaven.

And then it's my turn.

 (pause)

Um. Wait. Sorry.

Are you bored?

I just got scared you were bored again.

When it's a phone session I can't tell if you're—

(pause)

Uh-huh.

(long pause)

Okay.

Um.

So I'm up next. And suddenly I'm surrounded by all these shelves and on every shelf is every movie I've ever seen. And like some are like DVDs and others are like old VHS tapes from like the '90s and some are even like old thirty-five-millimeter reels, like movies I saw in the theater. And like— yeah. Everything is there. Like The Wizard of Oz, which is the first movie I ever saw. And like old Jim Carrey movies and the entire Criterion Collection . . . and then they hand me the ISBN scanner and I realize, like, I realize that the way they decide whether or not you get into heaven is through, like, looking at all the movies you've ever watched or all the books you've ever read and figuring out whether there was one book or movie that you truly truly loved. Like one movie that like symbolizes your entire life.

And I think, okay, I'm gonna be fine. I love movies and I've seen all these like awesome movies, this is gonna be no prob-lem, and I start running the scanner across the shelves. I run it across all these Yakuza movies I watched in high school, I run it across all the Truffaut movies, and the scanner isn't beeping. It's weird. It's not recognizing anything. And then I run it over Pierrot le Fou and Barry Lyndon, and I've seen those movies like literally dozens of times, and it doesn't beep. And we're going past hundreds of movies. Really good movies. Movies I like really really love. And I start getting nervous. There's only a couple shelves to go. And I run the scanner over Andrei

Rublev and nothing happens. And then I run it over Fanny
and Alexander and I can't believe it, but . . . nothing happens.
And then I think to myself: I'm going to hell.
I haven't truly like, loved or whatever in the right way,
I thought I did, but I didn't, and I'm going to hell. And then
I'm on the last shelf of movies and I've already like completely
lost lost hope at this point but then suddenly the scanner starts
beeping and beeping and I look at the movie that made it beep
and it's this like old cruddy VHS tape of Honeymoon in Vegas.

(*pause*)

Honeymoon in Vegas?

(*pause*)

It's like this terrible movie with Nicolas Cage and Sarah Jes-
sica Parker from like 1989. I was obsessed with it when I was
like four. I watched it at my cousin's birthday party.
It's like a really really bad movie.

(*pause*)

And at first I'm like: what? My entire life can be represented
by Honeymoon in Vegas? Honeymoon in Vegas is like the one
movie I truly truly loved? But then I'm like, wait, it doesn't
matter, I'm going to heaven. I must have done something
right in my life because I'm going to heaven.
And that feeling of like . . . of like knowing that I made the
right choices, was like the best feeling I've ever had.

(*a long pause*)

Yeah.

(*pause*)

Yeah.

A long pause.

AVERY

. . . Okay.
I guess like . . .

Well, yesterday I had this thought.

I was like: okay.

Maybe it's never gonna get better.

Maybe I'm gonna live with my dad for the rest of my life and like the *actual* problem is just that I'm waiting for things to change.

Like maybe I'm just gonna be that weird depressed guy and I should just like accept it.

And that'll be the life I get.

And that'll be okay.

> (*a long pause*)

Yeah.

> (*he laughs and rubs a few tears out of his eyes*)

Yeah.

> (*pause*)

No. That's okay. I think I can wait until Tuesday.

> (*pause*)

Uh-huh.

Well, I hope you're having a good vacation.

Sorry that you have to talk to me during it.

> (*he winces, pause*)

No, I didn't . . . sorry. Yeah. I know that.

I was just—

It was like a stupid joke.

> (*pause*)

Yeah.

I know that.

Yeah.

He listens intently. Blackout.

SCENE SEVEN

A day later. Sam and Avery are standing, holding their brooms, in the middle of the aisle. They are gazing up at the tile ceiling, which now has an ominous gap in it.

SAM

. . . It happened on Sunday.

They stare at it for a while.

SAM

Brian and Rebecca are working, it's the matinee, ho hum, ho hum, there's just a few people in the audience, and out of nowhere this huge chunk of tile . . .
 (he points to the gap in the ceiling)
. . . comes crashing down and LANDS ON THE SEAT NEXT TO SOME OLD LADY.

Like two more inches to the right and she'd be dead.
Apparently there was plaster all over her old lady sweater.

AVERY

Did she—she could sue, right?
Can you sue over that kind of thing?

SAM

Probably. Probably. But Brian is like this huge charmer, apparently Brian just like *turned on the charm* and calmed her down and gave her a voucher for like six free popcorns and six free sodas which by the way he just like drew himself on a receipt or something so if an old lady comes in with a weird cartoon that says she gets a free popcorn or soda give it to her no questions asked.

AVERY

He didn't even give her free tickets?

SAM

He didn't even do that.

They gaze up at the ceiling for a long time.

SAM

It's a liability.
It's a huge liability.
It's—someone's gonna get killed and then what.

AVERY

Can't he just put in a new ceiling?

SAM

Well.
These are the questions a normal person would ask.

But we're talking about Steve.
Steve will never spend a dime on anything.
Steve would rather this place burn down than he like spend a little money to make it safe or have a nacho machine at concessions.
Wouldn't that be nice?
If we could make those nachos with the little cheese squirter thing?
I keep telling him to get one of those.

They go back to sweeping.

SAM

We haven't sold out a single show since Slumdog Millionaire. It's pathetic.

They sweep for a while. Silence.

AVERY

Oh.
So. Uh.
I went up to the booth the other day and I, uh . . .
I didn't realize there were so many old reels up there.

SAM

Oh yeah. Steve's such a sketchball. He's supposed to send them back to the distributor. And they're all like sitting up there collecting dust. Some of them are really old.

AVERY

There's a lot of good stuff up there.

SAM

I guess.

 AVERY

I uh . . .

This is probably a stupid idea.

But.

Uh.

I was thinking that on uh . . .

I was thinking on Friday it might be fun to like . . . we could
like just stay here after the last show and watch one or two of
em.

 (short pause)

Like I saw Goodfellas and Boogie Nights and a couple other—

 (nervously)

It would just be awesome to see them on like the big screen.
I've only watched Goodfellas on my computer which is pretty
like blasphemous when you think about it.

 (pause)

It's fine if like you're busy or not interested or whatever.

Sam is still sweeping.

 SAM

No. No. That sounds . . . that sounds cool. I just uh . . . I'm
not gonna be here this weekend.

 AVERY

Oh.

 SAM

Yeah. Rose will be here if you need help with anything . . .
Steve didn't tell you?

 AVERY

No.

SAM

Uch. He's an idiot.

(a short pause)

Yeah. It's not that hard with two people. Rose will come early and help you with setup and box office and stuff and then you'll just do clean-up on your own.

AVERY

Oh. Yeah. / Okay—

SAM

You've been here three weeks so I assumed you felt comfortable with everything / and—

AVERY

Oh, yeah. Yeah. Sure.

SAM

Steve should pay you double but of course he won't. So you'll just get my Dinner Money.

AVERY

You don't need / to—

SAM

No, that's the way it works.

Pause.

AVERY

Where are you going?

A short and unnecessarily weird pause.

 SAM
. . . My brother is getting married.

 AVERY
Oh! Wow.

 SAM
Yeah.
In Connecticut.
Right outside Bridgeport.

 AVERY
Congratulations.

 SAM
Yeah.

 AVERY
And your whole family is going?

 SAM
Yeah. Yeah.

 AVERY
Cool.
 (pause)
Older or younger?

 SAM
What?

 AVERY
Older or younger?

SAM

Oh. Um. Older.
Yeah.
He's thirty-nine.

Pause.

AVERY

Do you like the woman?

SAM

What?

AVERY

Do you like the woman he's marrying?

SAM

Uh. Yeah. I mean, I don't know. I've never met her.

AVERY

Oh.

A long silence, during which they go back to cleaning.

AVERY

What's your brother's name?

SAM

Jesse.

A long pause while they keep cleaning.

SAM

(*casually*)
He's retarded.

A short, confused pause.

<div align="center">AVERY</div>

Do you mean / like he's—

<div align="center">SAM</div>

Like in the actual definition of the word.

<div align="center">AVERY</div>

Oh! Okay.

<div align="center">SAM</div>

She's retarded too.
The woman he's marrying.

<div align="center">AVERY</div>

. . . Okay.

<div align="center">SAM</div>

They met at this uh residential uh facility in Connecticut.

<div align="center">AVERY</div>

Cool. Cool.

<div align="center">SAM</div>

Yeah.

<div align="center">AVERY</div>

Um. They must like each other a lot.

<div align="center">SAM</div>

I guess.

Pause.

AVERY

Is it . . . does he have Down's / syndrome?

SAM

No.
He's just uh—
He's basically like the—he's basically like a third grader.

AVERY

Oh.

Pause. More sweeping.

SAM

(a confession)
I don't know him all that well.

Rose enters with a yo-yo.

AVERY

(trying to politely end the conversation)
Well!
Next weekend maybe.

ROSE

Next weekend maybe what?

AVERY

Uh.
We were thinking of staying past closing on Friday and watching Goodfellas.

ROSE

Oh yeah. We have that upstairs.

AVERY

But Sam's gonna be away so I was saying maybe / next—

ROSE

I'll stay and watch it with you.

Sam, who has been standing in the second row, sits down heavily in one of the seats and closes his eyes.

AVERY

(glancing over at Sam)
Oh . . . Uh—
I don't know . . . maybe we should wait for Sam and then we can / all—

ROSE

Well we don't have to watch Goodfellas. We could watch something else. There's Mulholland Drive. That movie is hot. And some older ones too from before it was The Flick.
I'm totally free on Friday. Let's do it.

Sam's face is no longer visible to Rose and Avery; he faces the movie screen and stares up at it, beseechingly.

AVERY

Uh. Yeah. Sure. Okay.

ROSE

Awesome.
Yes.
We should like bring music and have like a rockin dance party.

Sam closes his eyes.

ROSE

Hey. Look what I like unearthed from my closet.

She holds up the yo-yo.

ROSE

I'm totally gonna bring the yo-yo back in style.

She yo-yos for a while, a simple up and down.

ROSE

I only know how to do this, though.

AVERY

Here. Let me try.

*Rose gives Avery the yo-yo and he does something sort of impressive . . .
maybe he Walks the Dog? Or flips it around and catches it.*

ROSE

YES!! OH MY GOD!! I love it.

Avery hands it back to her, blushing.

ROSE

Where are you gonna be this weekend, Sam?

SAM

(flatly, still facing forward)
. . . My brother's wedding.

ROSE

Where?

Bridgeport.

ROSE

Cool.

Rose glances at the back of Sam's head, clocking that he's being a little weird, and then exits. Avery gathers up his broom and dust pan and heads toward the door.

AVERY

Hey. Uh. I keep meaning to ask. Did you ever find out what was going on with your skin?

Sam is still sitting and facing forward during the next speech.

SAM

Yeah.
I went to the doctor.
 (a short pause)
It's called Pityriasis rosea.
 (a short pause)
It's not contagious.
 (a short pause)
It looks like a fungus but it's not.
 (a short pause)
They don't know what causes it but you get it all over your torso and it itches like fuck and it lasts six to eight weeks.

AVERY

Ah man.

SAM

The good news is you only get it once in your life.

He stands up and lifts up the back of his shirt so Avery can see it.

<div align="center">AVERY</div>

Whoa!

<div align="center">SAM</div>

The spots make like a—if the spots are in a distinctive Christmas tree formation you know it's Pityriasis rosea.

<div align="center">AVERY</div>

Wow. Wow. That looks pretty bad.

Sam lowers his shirt.

<div align="center">SAM</div>

 (depressed)
Yeah. It's not though.

<div align="center">AVERY</div>

You want box office or refreshments?

A long pause while Sam contemplates this.

<div align="center">SAM</div>

Box office.

After a few seconds, Sam slowly gets up and they start to exit together. Rose enters the projection booth and we see her moving around in the window.
Sam stands in the aisle and looks up at her.
Avery waits by the door.
Sam tears his gaze away from the projection booth, and they leave together. The door slams shut.
Blackout.

SCENE EIGHT

Friday night. Darkness. The last movie is ending. The very end of the credits. A flash of green. A flash of white. Then the lights come on automatically. We see Rose in the projection booth.

After a few seconds Avery enters, dragging the yellow mop bucket and mop.

He starts cleaning.

He starts on his side of the aisle and mops. He encounters a large popcorn bag and throws it away. He mops more.

He glances up at the projection booth. Rose is moving around, doing something. She sees him and pumps her fist in the air in a "we're gonna party" gesture. Avery tries to smile.

He moves to the other side of the theater and starts cleaning.

Rose knocks on the window and holds up a CD, wiggling her eyebrows. Avery shrugs and shakes his head, like, "what are you saying?"

Inside the projection booth (we probably can't see this), Rose inserts the CD into the sound system.

An extremely danceable hip-hop classic from the past decade comes blasting into the theater. Maybe Jay-Z's "I Just Wanna Love U."
Avery is startled. He tries to keep sweeping. He's not sure what is happening.
Rose leaves the projection booth, and ten seconds later kicks through the door, grooving to the music.

ROSE

Dance Party!!

Avery laughs anxiously.
Rose grooves down the aisle. Avery bobs his head up and down, trying to look supportive.

ROSE

Come on!!

Avery shakes his head no, still bobbing supportively.
Rose rolls her eyes, disappointed, but then proceeds to do a totally awesome improvised dance in the aisle and maybe even in some of the rows. She's really wild and weird and uninhibited. It's pretty cathartic. It should be different every night. Maybe she incorporates a couple moves from bhangra and/or hip-hop and/or West African dance classes from her past. This lasts about two minutes. Avery stands in his row, bobbing his head the whole time.
Finally Rose tuckers herself out. The song is still blasting.

ROSE

WHEW!

She runs out of the theater and up to the projection booth, where she turns the music off. Then she comes back down and reenters.

ROSE

. . . Aaaanyway.

AVERY

That was great.

ROSE

Yeah.
Whatever.
I feel like an idiot now.

AVERY

No, no.
Sorry I didn't like—
Sorry I didn't like join in.

A weird pause.

ROSE

So what do you wanna do?

AVERY

Oh.
Ah.
We could watch a movie?
Or—

ROSE

You wanna get stoned?

AVERY

Ah . . . no. Thank you.

ROSE

You sure?

AVERY

Yes.
I get really . . . I get really freaked out. I get really angry.

ROSE

Awesome.

AVERY

No. Not awesome. I like sit in a corner and refuse to talk to anyone.

(a short pause)

The last time I smoked pot it was the end of freshman year at this like huge party and I like found this guy's collection of Calvin and Hobbes and sat in his closet and read them all night and if people tried to talk to me I was like: LEAVE ME THE FUCK ALONE!!

ROSE

You go to Clark, right?

AVERY

Yeah. Well. I took this past semester off. But yeah.

ROSE

Expensive.

AVERY

I actually have a free ride.

ROSE

Really?

AVERY

My dad teaches there. He's head of his department, so—

ROSE

What does he teach?

AVERY

Uh. Linguistics . . . Semiotics . . .

ROSE

I have no idea what that is.

AVERY

(trying to laugh)
Yeah.

ROSE

I went to Fitchburg State.

AVERY

Cool.
Cool.

ROSE

You still live at home?

AVERY

Oh. Well. Yeah. For now, while I'm taking time off from Clark, but when I go back / I'll—

ROSE

I'm not judging. I lived at home until I was twenty-one.
(pause)
Sam still lives at home.

AVERY

He does?

ROSE

Yeah.

AVERY

Huh.

ROSE

When he first started working here he had this like super-controlling girlfriend and I think he lived with her in like Athol or something? She would like show up and like give me these insane paranoid looks. You know, like one of those women who's always like: "are you gonna steal my boyfriend?!"
And then they broke up—I think he broke up with her?—and he moved back in with his parents. He lives in the attic or something.

AVERY

Huh.
I guess he like . . . he doesn't tell me a lot. He seems pretty private.

ROSE

Yeah. He's weird.

AVERY

I mean, I like him a lot.

ROSE

Yeah. I mean, me too.

Pause.

AVERY

Did you know that his brother is retarded?

ROSE

WHAT?!!

<div align="center">AVERY</div>

Yeah. Oh. Maybe I shouldn't have told you that.

<div align="center">ROSE</div>

REALLY?!

<div align="center">AVERY</div>

I mean it's not a big deal.

<div align="center">ROSE</div>

I did *not* know that.

Pause.

<div align="center">ROSE</div>

Like how is he retarded?

<div align="center">AVERY</div>

I don't know.
I mean, I think he's just um . . .
 (a pause)
I think he's just retarded.

Pause.

<div align="center">ROSE</div>

My ex-boyfriend had a cousin with Down's syndrome and she always liked to flash people her tits.
Like I went to their family reunion this one summer and she like flashed me her tits like seventeen times.
And I would be like: "awesome, Ruth, thank you" and I would try not to like stare at her like weird nipples.

A long pause, in which Avery does a number of mental calculations.

 AVERY

Your ex-boyfriend?

 ROSE

Yeah.

 AVERY

Huh.
For some reason I uh . . .

Pause.

 AVERY

I think someone told me that you were, uh . . .
I think someone told me that you were gay.

 ROSE

Oh.
No.
I mean, whatever, I've been with girls a couple times.
But no.

Long weird pause.

 ROSE

You wanna watch a movie?

 AVERY

 (relieved)
Yeah! Yes. Definitely.
Hey. Uh. Would you ever show me how to use the projector?

 ROSE

It's just like a shitty old thirty-five-mill.

AVERY

No, no . . . I'm like . . . that's why I wanted to work here. This is one of the only theaters left in Worcester County that has— yeah. I'm obsessed with film, and like old . . .
I actually refused to work at any of the theaters that just do digital.

ROSE

But everything's gonna be digital. In like six months. Seriously. Steve is an idiot. If he doesn't go digital or sell this place in the next year it'll shut down.

AVERY

Yeah, I like . . . I guess I disagree. Or like, I think that's really immoral.

ROSE

What is?

AVERY

Projecting a movie made on film through a digital projector.

ROSE

I dunno.
 (short pause)
I mean, I guess I personally like . . . like apart from this job I never go to the movies.
 (short pause)
I'm kind of over movies.
 (short pause)
I used to be super into them but now I'm over them.

This is all really depressing Avery.

ROSE

You're totally obsessed with them, aren't you?

AVERY

Yeah.
I mean. ·
They're like my life.

ROSE

Huh.

A short pause.

ROSE

Well, I'll show you how to do it. You can fill in for me when
I'm sick or whatever and then eventually Steve'll promote you.

AVERY

Seriously?

ROSE

Yeah. Sure. Sam keeps bugging me to show him how to do it
but I bet you'd be better cuz you're so obsessed with it.

*Rose starts walking up the aisle. Avery stays back, guiltily, thinking
of Sam.
She turns around.*

ROSE

Come on!

*He follows. They leave the theater, disappear for about fifteen seconds,
and then reappear in the window of the projection booth. They move
around, then disappear, then reappear with a giant reel of film.*

Through the window, we watch Rose teach Avery how to thread the projector. He probably does it himself while she watches and provides instructions. He is smiling. They finish threading the projector. They turn it on. A movie begins; we see the green light, then blackness, then the opening credit sequence, music. It is the six-minute-long opening-credit-sequence music from The Wild Bunch.

Avery watches the beginning of the movie, his face almost pressed up against the projection booth window, and then he and Rose exit and come through the theater door again.

Avery doesn't take his eyes off the screen while he walks down the aisle. He finds the third row, stage left, and sits in the center.

Rose follows him and sits next to him.

They watch the movie for about forty-five seconds.

Then Rose very slowly turns her face and looks at Avery. He notices this but continues watching the screen, attempting to appear nonchalant.

Rose keeps looking at Avery. Avery keeps looking at the screen.

After a while, Rose leans over and kisses Avery's neck.

Avery is frozen, still watching the movie. He does not move away.

Rose keeps kissing Avery's neck, contemplates nibbling his ear, decides against it, and goes back to looking at him.

Avery keeps watching the movie.

Rose takes her index finger and traces little stripes and circles on Avery's neck. Then she takes her finger and runs it in a straight line down Avery's shirt (or maybe she stops to make tiny circles around his nipples). Then her hand disappears from our view.

Avery is still watching the screen.

Rose unzips his pants and begins to touch him. Avery lets her touch him and does not take his eyes off the screen.

This goes on for a minute or so but something is clearly off and eventually Rose slowly takes her hand away and, mortified, goes back to watching the movie.

Avery keeps watching the movie. He might start crying. He doesn't. Eventually Rose gets up, walks up the aisle (Avery does not turn around), and ten seconds later we see her in the projection booth. She

*shuts off the movie and the lights in the theater automatically go on.
As if released from a spell, Avery bends over, elbows on knees, and
covers his face in shame.
He stays this way while Rose comes back downstairs, walks down the
aisle, and sits in the row across from him, in the aisle seat.
A long silence.*

ROSE

Sorry.

AVERY

No.
I'm sorry.

Short pause.

AVERY

Oh my god.
I wanna kill myself.

ROSE

Wow.
Thanks.

*Avery removes his face from his hands and looks at Rose. Another
long silence.*

ROSE

I um . . .
Yeah.
Wow.
We can just forget that this ever happened, okay?

Pause.

ROSE

I feel like I like *molested* you or something.

AVERY

You didn't molest me.

ROSE

Yeah.
I'm an idiot.
 (a short pause)
Honestly, I don't know why I even like *did* that.
I wasn't planning on doing that.
I swear to god.
 (a short pause)
There's something wrong with me.

AVERY

No, there's something wrong with *me*.

A long silence.

ROSE

Well are we just gonna like sit here and like freak out together
in silence?
Because then I'd / rather—

AVERY

It's just.
This has happened to me.
Before.

Pause.

AVERY

So don't feel—please don't feel / like—

ROSE

Yeah, but you weren't giving me the vibe and I went for it anyway.

A long pause.

ROSE

. . . So you / like—

AVERY

I just have a hard time.
Sometimes.
When like—my mind goes blank and I like . . .
I always just think: I'd rather be watching a movie.

His elbows go onto his knees and his face goes into his hands again.

ROSE

It's okay, Avery.

She moves across the aisle and sits next to him again.

ROSE

What do you think about when you, like, fantasize?

No response. After a pause:

ROSE

Do you ever think about / guys?

AVERY

I really don't want to answer these questions.

ROSE

Okay.
That's okay.

His face is still in his hands. Rose leans back in her seat, almost relaxed now, and props her feet up on the seat in front of her.

ROSE

Well, I'm fucked up too.

AVERY

(*muffled*)
Yeah?

Short pause.

ROSE

I can't stay attracted to anyone for longer than four months.

AVERY

. . . Huh.

ROSE

At first I'm like this like crazy nymphomaniac. All I want to do is like have sex all the time. Like eight, nine times a day.

AVERY

Whoa.

ROSE

And then it like totally goes away and I turn into like this like dead fish.
And then I like fake it until we break up.

AVERY

Huh.

A long pause.

ROSE

And you know what's even weirder?

AVERY

What.

ROSE

When I like fantasize I just like think about *myself*.

A short pause.

AVERY

Really?

ROSE

Yeah. Like everyone else is blurry except for me.
I'm like totally in focus.
And I like look amazing.
And everyone is like: holy shit.
That girl looks so amazing.

Pause.

ROSE

It's really embarrassing.

AVERY

I don't think it's embarrassing at all.

*Silence. They both are leaning back in their seats now, facing the
blank screen, peaceful, arms touching.*

AVERY

Can we just sit here for a little while?

ROSE

Yeah.
Yeah.
Of course.

A long, much more comfortable silence.

AVERY

Today is the one-year anniversary of the day I tried to kill myself.

After a pause:

ROSE

Really?

AVERY

Uh-huh.

Pause.

ROSE

How did you do it?

AVERY

I swallowed a bunch of pins.

ROSE

Oh my god.

Pause.

ROSE

That *works*?

<center>AVERY</center>

Well.
 (short pause)
I didn't plan on doing it.
 (short pause)
It was a weird day.

A long pause.

<center>ROSE</center>

Huh. I've been like super super sad before but I've never wanted to commit suicide.
I just like don't get it.
I don't get suicide.
It's like: aren't you curious what's gonna like *happen* to you? In like the future? I'm just like so curious about my future.

<center>AVERY</center>

Yeah.
You've probably never . . .

He decides not to say it.

<center>AVERY</center>

. . . You know what *I* don't get?

<center>ROSE</center>

What?

<center>AVERY</center>

Bulimia.

<center>ROSE</center>

Oh my god!! I know, right?!

AVERY

Barfing is so horrible.

ROSE

I know!! It's like / the—

AVERY

It's like the worst feeling in the world. It's like being in hell.

ROSE

I know! Like why would you like *voluntarily* . . . like if you're gonna like have an eating disorder just be anorexic.

Pause.

ROSE

This is an awesome conversation.

Pause.

AVERY

I almost quit my second day working here.

ROSE

Why?

AVERY

I just like . . . I couldn't get out of bed. The first day was just like really awkward and I couldn't remember anything and I like . . . I had no idea how to hold the broom—

She laughs.

AVERY

—I'm serious. And then I woke up the next day and just like freaked out. I was like: I can't have a job. I'm way too depressed. And I didn't get out of bed and I like lay there under the covers staring up at the ceiling and four P.M. rolled around, I like watched the numbers on my alarm clock, and I was like, I should be at The Flick by now, but I couldn't even bring myself to call in sick. And then it was like 4:05, and then it was 4:10, and I was like that's it, I just lost my first job, I give up. And then—it's weird—I didn't even make the decision—but it was like—the second I thought, like—I give up—my body started moving and I like pushed the blanket off and like stood up and put on my uniform and like walked outside and walked to the bus and took the bus and walked in here and made up some like lie to Sam about why I was late and that was it.

A long pause.

ROSE

So why are you depressed?

AVERY

Are you serious?

ROSE

Yeah.

AVERY

Um. Because everything is horrible? And sad?
 (*a short pause*)
And the answer to every terrible situation always seems to be like, Be Yourself, but I have no idea what that fucking means. Who's Myself? Apparently there's some like amazing awe-

some person deep down inside of me or something? I have no idea who that guy is. I'm always faking it. And it looks to me like everyone else is faking it too.

Like everyone is acting out some like stereotype of like . . . of like . . . exactly . . . who you'd think they'd be.

And I had one friend, one friend, at Clark, this guy from Bangladesh who was really into sculpture, and then he transferred to RISD at the end of freshman year.

After a short pause:

AVERY

And my mom like . . .
Actually never mind.

A long pause.

ROSE

Do you think *I'm* a stereotype?

AVERY

Of like—

ROSE

Of like—whatever.
Of like what I am.

AVERY

. . . Yeah.

ROSE

You do?!

AVERY

Yeah.

Pause.

ROSE

I guess you're right.

Pause.

ROSE

Uch.

Pause.

ROSE

Wait.
Were you being fake? Just now?

AVERY

When?

ROSE

When you were like . . . when you were going off about how
everyone is so fake. Were you faking it then?

AVERY

I mean yes and no.
It's hard to tell, I guess.

ROSE

Yeah.

*They look up at the blank screen and prop their knees up on the seats
in front of them. Maybe Rose puts her head on Avery's shoulder.
Blackout.
Jeanne Moreau singing "Le Tourbillon" plays.*

ACT TWO

SCENE ONE

Three days later. Sam and Avery, each on their side of the aisle, sweeping. Sam is in the middle of a seemingly big dramatic story.

SAM

—so the next day we all went to see a movie. I mean minus my brother and his girlfriend. Wife. We went to this huge like multiplex outside of Bridgeport.

AVERY

What movie?

SAM

The new Daniel Craig thing— / State of—

AVERY

Was it good?

SAM

It was okay.

It was okay.

Anyway. On the way there I stopped at this Mexican takeout place that I read about online. It's like this famous Bridgeport tamale place. And then . . .

I brought the tamales into the theater.

AVERY

You hate when / people—

SAM

I know. I know. This is the point of—I know. But we were in a huge hurry and I didn't want to eat them in my aunt's car cause she has this like pristine like fucking Passat that she's all obsessive about and I wanted to like you know you know pour the little cups of red and green salsa all over the tamales etcetera etcetera. So I decide to bring the bag of tamales with me into the movie theater. But then we can't find parking and we're you know late and there's a weirdly long line for tickets. And we don't actually sit down in the theater until halfway through the previews. So after we sit down I open my like styrofoam container and get in a few delicious bites of tamale before the movie starts. But then I put it away. Because I'm like you know like philosophically opposed to rustling your plastic bags and like squeaking your styrofoam container during the actual movie. So I put the tamales back in the plastic bag and I put the plastic bag on the floor.

And we're like five minutes into the movie when this woman comes like uh like waddling down the aisle into the theater. And this is gonna sound horrible but she's uh . . . she's like really really smelly. Like one of the smelliest people I've ever . . . uh, smelled. Like she's not homeless or anything, it's not

like the homeless pee smell, it's more like a . . . a kind of like
. . . it's kind of like a chunky cheesy kind of smell?

 AVERY

Oh god. Okay. I get it.

 SAM

And she sits right in front of us.
And I am . . . I am like *incredibly sensitive* to people's smells.
When I was a kid my dad had this friend who had halitosis and
I couldn't even like be in the same room as him.

 AVERY

Wait. Do you—
Have I ever smelled bad to you?

 SAM

You have never smelled bad to me.

 AVERY

You promise?

 SAM

I promise.
I mean a couple of times I smelled your very pleasant smelling
shampoo but that's it.

 AVERY

Okay.

 SAM

Anyway, this lady sits down right in front of us and her cheesy
smell keeps coming at me in like waves and I can't focus on the
movie and I start going crazy. And my mom and I are whisper-

ing about it and then we convince my dad and my aunt and my cousins that we should move seats. And so we all get up like a bunch of assholes and move five rows back.

<div align="center">AVERY</div>

Did you bring the tamales with you?

<div align="center">SAM</div>

That's the—no. I didn't. The point is that I was so freaked out by not being able to pay attention to Daniel Craig and getting away from the smelly woman that I totally forgot all about the tamales. And then we watch the movie and then it ends and the credits are rolling. And we're all collecting our things and getting ready to go when I notice these middle-aged ladies five rows in front of me, not the smelly lady, the ladies who were sitting to the left of us originally, and they're all getting ready to go.

And they start walking towards the aisle and then one of them goes, "Linda, are these yours?" And the other one goes, "No. Trish, are they yours?" And Trish or whoever is like, "No I didn't bring anything in." And I look and I see they're holding up my bag of tamales.

And then I realize: I'm that douchebag.

I'm that douchebag who brings like random weird ethnic food into a movie theater and then forgets about it and leaves it there! I am my own worst nightmare!

And I sit there paralyzed, watching them ask each other, is this yours? is this yours? and I'm too scared to say anything and then eventually Linda or whoever just takes the bag and they all walk up the aisle together and when they get to the doors *she throws it in the trash.*

She throws it away for me.

Pause.

AVERY

Okay . . .

Pause.

SAM

That's the story.

AVERY

I don't get it.

SAM

It's like . . . it's like I was dead or something. I was watching the world like go on without me.

AVERY

But if you were dead you wouldn't have left the bag of tamales / on the—

SAM

No. But I was like . . .

A long pause.

SAM

It all made more sense in my head.

Pause.

SAM

It was like a really good story in my head.

Pause.

<div align="center">SAM</div>

It felt like some profound like realization and now I can't remember what the realization was.

Rose enters.

<div align="center">ROSE</div>

How was the wedding?

<div align="center">SAM</div>

Oh.
It was okay.

<div align="center">ROSE</div>

What'd you wear?

<div align="center">SAM</div>

Uh . . . a suit.

Pause.

<div align="center">ROSE</div>

Soooo . . .
I think Steve's trying to sell it.

They look at her.

<div align="center">ROSE</div>

The Flick.
I think he's trying to sell it.

<div align="center">AVERY</div>

. . . No.

ROSE

I came in early yesterday and he was here with some like businessy guy talking about how the lobby had "promise." Then after the guy left I was like what the fuck is going on and Steve was like "I might be moving to Tucson."

SAM

Whoa.

ROSE

I bet he's selling it cause he can't get any distributors to send him stuff anymore.

AVERY

Who would he sell it to?

ROSE

I don't know. Probably Fuckface 500.

AVERY

You mean Loews? AMC?

ROSE

I have no idea.

SAM

Huh.

AVERY

He can't sell it.
That would be like one of the saddest things of all time.

SAM

Uh . . .
I think the *Holocaust* is one of the saddest things of all time.

AVERY

The big guys wouldn't buy it. It's just one screen. It wouldn't make financial sense.
It must be a smaller chain.
It was just one guy with him in the lobby?

ROSE

Yeah.

AVERY

Did he say anything about going digital?

ROSE

Nope.
I didn't ask.

AVERY

If he goes digital your job will be obsolete.

ROSE

I'll be happy if he sells it.

AVERY

Why?

ROSE

Because this place is a piece of shit. And Steve is a retard.

Then she catches herself and blushes.

ROSE

(to Sam)
Sorry.

Pause.

ROSE

I'm gonna go upstairs.
 (to Sam)
I'm glad you had a nice time with your family.

She leaves. Sam clocks all of this, frowns, then dumps something in the trash.

AVERY

That's unbelievable. If they go digital I might have to like . . .
I might have to quit.

Pause. They go back to cleaning, then:

SAM

Did you tell Rose about my brother?

Pause.

AVERY

You / mean—

SAM

You know what I mean.

Pause.

AVERY

Uh—

SAM

Yeah. It's cool. It's cool. I just like mentioned that to you in confidence, you know?

Pause.

AVERY

Sorry.
I didn't know.

SAM

You didn't know *what*?

Pause.

SAM

Did you tell her like—what did you tell her?

AVERY

I just said that he was um . . .
 (pause)
I'm really sorry.

Pause.

SAM

Yeah. Whatever.
Who cares.
I just had like a fucking shitty weekend.
I hate weddings, anyway, so.

Pause.

SAM

My mother went like way over the top. It was disgusting.
It was like—you're the one who fucking sent him away and
then there were like—there were like cookies in little cloth
bags with like my brother and his wife's like fucking initials
stenciled on them.

And it's like, great, Mom. Now you have even more fucking credit card debt.

Pause.

SAM

And it was like—everyone was acting so happy.
Like trying so hard.
Like oh this whole fucking charade is so fucking joyful.
 (pause)
And it's like the only *actually* happy people here are retarded!
The rest of you are just miserable fucks.

Long pause. They sweep.

SAM

And everyone always pretends like the catering is so good!
Like oh my god the food is so *good*, isn't it?
And I'm like: it was shitty!
It was shitty lukewarm food cooked for 115 people!
Can't we just admit that wedding food is always a little shitty?

Pause.

SAM

If I ever have a wedding I'm gonna like have food trucks come and like set up outside the wedding tent and people can line up one by one and order tacos.

AVERY

That sounds good.

SAM

Maybe like one taco truck and then one shawarma truck.

AVERY

I would do massive amounts of take-out Chinese.

SAM

Huh.

Pause.

SAM

Did you have a good time with Rose?

AVERY

Yeah. Sure.

SAM

What'd you watch?

AVERY

Oh. Uh.
The Wild Bunch.
Yeah.
She'd never seen it before.
Jesus.
If Steve sells this place to some like chain that'll be so depressing.

SAM

Did you guys like hang out afterwards?

AVERY

Uh. A little.

SAM

Why are you being weird?
Did you guys like give each other like *handjobs* or something?

AVERY

(laughing)
No! God, no.
Jesus.
Sam.
We just talked.

SAM

What'd you talk about?

AVERY

Nothing.

A pause. More sweeping.

AVERY

Oh.
I thought you might be—
It turns out she's straight? Or bi. I'm not sure.

SAM

Excuse me?

AVERY

I mean, not that it matters.
But she told me that she's not a lesbian.
Didn't you say she—

Rose enters.

ROSE

Avery. I forgot.
Can you cover for me for the first hour on Thursday?
I know, I'm already taking advantage of you.

<center>AVERY</center>

(quick paranoid glance at Sam)
Uh. Sure. Yeah. Of course.

<center>ROSE</center>

Cool.
Oh, and I illegally downloaded that Four Nights of a Dreamer movie.
You're right.
It was *amazing*.

She leaves.
A long silence. Sam stares after her, then turns to Avery and stares at him.
Avery tries to say something but is too terrified.

<center>SAM</center>

Did she show you how to use the projector?

Pause.

<center>AVERY</center>

Well. I was really curious. I mean. I was actually just interested in how it *worked*, not um in um getting promoted or anything but then she said she could train me to be the uh the uh alternate and I didn't feel like I could—

Sam picks up a half-eaten bag of popcorn from his side of the theater, walks slowly across the aisle to Avery's side of the theater, rips the bag open and then flings it gloriously into Avery's area, popcorn showering everywhere.
Then he stalks out of the theater and slams the door behind him.
Avery stands there for a while.
Rose moves around in the projection booth, threading the next film into the projector.
Blackout.

SCENE TWO

The end of the night.
Sam and Avery are in the middle of mopping.
Sam is giving Avery the silent treatment.
They mop in terrible silence together.
Occasionally they each have to go squeeze out their mop in the yellow
bucket and listen to the horrible squeezing dripping sound.
Then the sound of the mop slopping down against the floor.
This goes on for a while.
Rose is in the projection booth, moving around, unwinding the film.
She comes downstairs.
She sits on the edge of a seat in the last row, Avery's side.
She takes some money out and counts it underneath her breath.

ROSE
Ten, twenty, thirty, thirty-three . . .
God.

(pause)
Eleven each.

She hands money to Avery. She walks over to Sam and tries to hand him money, but he is furiously mopping. She puts the money down on the armrest of the seat nearest to him.

ROSE

Could one of you give me a ride home tonight?
My sister borrowed my car.

Sam continues mopping. After a pause:

AVERY

Oh. Um. My dad is picking me up.

ROSE

Sam?

He doesn't respond. He continues mopping.

ROSE

Sam.

No response.

AVERY

But.
Um.
I guess I could ask him if he'd take you back to Boylston.

ROSE

Sam.
What the fuck.

Sam mops some more. Then he walks over to the mop bucket. He squeezes the mop in the mop bucket with tremendous power. Then he dips it in the water and squeezes it again.
Rose and Avery watch him do this. Sam does not take his eyes off the mop when he finally says:

SAM

(quietly)
Why'd you show Avery how to use the projector.

Pause.

SAM

What the fuck is *wrong* with you.

AVERY

Uh.
I'm gonna go to the bathroom.

Avery walks up the aisle and leaves. Rose is looking at Sam. Sam is staring into the dirty mop water.

ROSE

I didn't know you / wanted—

SAM

Yes. Yes you did.
I've been working here for almost twice as long as you and you know Steve only promoted you first because he thinks you're hot. And three months ago I asked you if you would train / me and you said—

ROSE

Okay. Okay.
You're right.
I'm sorry.

ANNIE BAKER

SAM

Do you know how humiliating it is to be working with like *twenty*-somethings who are rising in the ranks of your shitty job faster than you are?

Pause.

ROSE

I'm sorry.
It's—
I was stupid. I wasn't thinking.
I just—
I can train you too. Then if I get sick you can / take turns—

SAM

No. No way.
I'm not interested anymore.

Pause.

SAM

No fucking way.

ROSE

O*kay.*

Pause. Sam is starting to look ill.

ROSE

So. What.
Are you gonna like hate my guts now?

After a pause:

SAM

(quietly)
Oh god.

ROSE

What's going on?

SAM

I feel sick.
I feel like I'm gonna . . .
Oh my god.

He sits down in one of the front rows and faces the movie screen, away from Rose.

ROSE

Sam.

Silence.

SAM

I just . . . I can't stand it. I can't do it anymore.

Pause.

SAM

It's making me nauseous. It's making me sick.
 (a short pause)
I'm like breaking out in fucking rashes.

ROSE

I have no idea what you're talking about.

SAM

You don't?

Pause.

SAM

Really?

A long silence.

SAM

I like—I fucking love you.

Pause. Sam is still looking out at the movie screen.

SAM

I don't even know why.
You're like . . .
I see all these things that are wrong with you.
But it's like—

Pause.

SAM

It's really bad.
It's really bad.
It's not like a—
It goes way beyond the word "crush," or like—
I want to like—
I can't sleep.
I mean, I haven't really slept for like the past year and a half.
And then when I do sleep I dream about you. And you're like talking to me. Or like fucking some other guy. Or standing in front of me in like a motel room like brushing your teeth.
 (*a short pause*)
It's never been like this before.
I walk down the street and all I'm thinking is:

Rose.
Rose.
Rose.
It's like the fucking soundtrack to my life.
Just your name makes me like . . .

Silence.

SAM

I've pictured saying this to you.
I've pictured saying it so many times.

Pause. He does not turn around. They are both very still.

ROSE

So what do you want?

Pause. He is still facing forward.

SAM

What do you mean?

ROSE

Like what do you think is gonna happen now?

Pause.

SAM

I don't know.

Pause.

SAM

I guess I just . . .
I guess I needed to get it off my chest.

ROSE

But is this the kind of thing where you want the person to love you back or you actually secretly *don't* want them to love you back?

Pause.

SAM

That's a good question.

ROSE

Because it sort of seems like it has nothing to do with me.
Like *me* me.
You know?

Pause. Sam's heart breaks.

SAM

That's not how I wanted it to seem.
Be.
That's not how I wanted it to be.

Rose sighs a long, sad sigh.

ROSE

Like—
Like even right now. It's like you're performing or something.

Pause.

SAM

I'm not performing.

Pause.

 SAM

I'm not performing.

 ROSE

So turn around and look at me.

Pause.

 SAM
 (tears starting to brim in his eyes)
Do you like me back?

 ROSE

Oh my god.

Pause.

 ROSE

Would you please just turn around?

Sam shakes his head no.

 ROSE

Sam.

He shakes his head no again.

 ROSE

You're seriously not going to turn around and look at me?

He does not turn around.

 ROSE

You don't know me.

Like for whatever reason you like me . . . I'm not like . . . I'm
not like like that at all.

 (a short pause)

Trust me.

 (a short pause)

Okay?

Avery bursts through the door, trying not to dry-heave.
Rose and Sam stand up.

<div align="center">AVERY</div>

Oh my god.

They stare at him.

<div align="center">AVERY</div>

Someone took a . . .
Someone took a shit on the floor of the men's bathroom and
they—

He is bent over.

<div align="center">AVERY</div>

And they spread it all over the—
It's all over the walls and it—

He tries to breathe.

<div align="center">AVERY</div>

I just puked. I just puked on the floor of the bathroom. I feel
like I'm gonna—

Sam walks up the aisle and takes Avery's arm.

<div align="center">SAM</div>

You gotta sit down.
You gotta sit down and put your head between your knees.

Avery sits down and puts his head between his knees.

<div align="center">SAM</div>

You gotta breathe.
Take deep breaths.

<div align="center">AVERY</div>

Oh god.

<div align="center">SAM</div>

I'm gonna take care of it.

He grabs the mop.

<div align="center">SAM</div>

You just take it easy.

<div align="center">ROSE</div>

I'll help.

<div align="center">SAM</div>

No. No.
 (firmly)
You stay here and you watch him and you get him water. I'm
gonna take care of it.

<div align="center">AVERY</div>

You're gonna have to—
Now my puke is all over the place.

(his head swimming)
I'm so sorry.
Are you still mad at me?

SAM

It's fine. I'm not mad at you.

AVERY

It's everywhere.
Why would somebody *do* that?

SAM

This happens.
This kind of thing happens in movie theaters.
I'm gonna deal with it.

AVERY

But you have such a sensitive sense of smell!

SAM

Avery.
Don't worry about it.
I'm totally cool with puke.
I'm totally cool with shit.
I'm gonna take care of it.

Sam walks up the aisle toward the door. Before exiting he stoically thrusts the mop up into the air like a sword.

SAM

I'm taking care of it!

And he exits.
Avery bends over and breathes.
Rose watches him.

ROSE

You want a cup of water?

AVERY

Yeah.
(he breathes)
That would be great.

She watches him for a while.

ROSE

Avery.
Please don't tell Sam about what happened the other night.

AVERY

Of course.
I mean.
You don't either.

ROSE

I won't.

Pause.

AVERY

Can I still fill in for you on Thursday night?

She considers this.

ROSE

I'll make it work.

Pause.

<div align="center">ROSE</div>

Sometimes I worry that there's something really, really wrong
with me.
But that I'll never know exactly what it is.

<div align="center">AVERY</div>

Uh.
No. You're fine.

<div align="center">ROSE</div>

Really?

<div align="center">AVERY</div>

Yeah.

Pause.

<div align="center">ROSE</div>

I'll get you some water.

Rose walks out of the theater to get water. Blackout.

SCENE THREE

Sam and Avery, mid-walkthrough. Rose is in the projection booth, moving around. Occasionally she stops and tries to casually peer out at them.

SAM

Have you seen this video everyone is putting up on Facebook? The one where the water bottle starts talking back to the woman?

AVERY

Uh . . . no.
I'm not on Facebook.

SAM

Oh.

Pause.

<center>SAM</center>

That's funny. I looked for you once and couldn't find you. But then I thought that maybe you were "invisible."

<center>AVERY</center>

I mean, if I was on Facebook we would be Facebook friends. I mean, I would've friended you by now.

<center>SAM</center>

Sure. Sure.

Pause.

<center>SAM</center>

What's the objection to Facebook?
Actually. Never mind. I'm tired of hearing the objections to Facebook.

They go back to sweeping. Then:

<center>AVERY</center>

I was on it. For a little while. When I was a freshman. But then my mom got on it because I was on it and she started reconnecting with all her friends from high school and then she reconnected with her high school boyfriend and they started writing each other letters and then she left my dad for him.

Pause.

<center>SAM</center>

Wait, seriously?

<center>AVERY</center>

Yeah.
She moved to Atlanta a year and a half ago.
To be with him.

SAM

To be with her high school sweetheart??!!

AVERY

Yup.

A short pause.

SAM

How do you feel about that?!

AVERY

I mean. She's like . . . she's like a terrible person.
That's how I feel about it.

SAM

Have you visited her there?

AVERY

Nope.

SAM

You haven't seen your mother for a year and a half?!

AVERY

She came back. A year ago. To visit. When I like . . . when a
bunch of stuff happened in our family. But I didn't want to talk
to her. I didn't even want to like look at her.

Pause.

SAM

Whoa.
Whoa.

Pause. They sweep.

SAM

For some reason I pictured that you came from a like perfect family. That like everyone in your family is super close and happy and that you all like wear the same glasses.

AVERY

Uh. No.
I'm the only one with glasses.

Pause.

SAM

You probably should go visit her at some point.

AVERY

I'm not interested.

They sweep for a while. Then Sam takes his iPhone out of his back pocket and fiddles with it. Then he looks over at Avery.

SAM

So you wanna see this?

Avery nods, then walks over to Sam. Sam holds the phone out in front of Avery and presses play. We hear the faint noises of the video but cannot make out anything concrete.

SAM

Okay.
Just . . .
Keep watching.
It gets funny in like fifteen seconds.

Fifteen seconds pass. A grin spreads across Avery's face. Sam starts to giggle.

<div align="center">SAM</div>

Right?
Ah ha ha ha!

Avery nods and grins and maybe silently shakes with a little laughter. The video continues.
They watch for a few more seconds and then Sam heaves a satisfied sigh, takes the phone, and puts it back in his pocket.
They head to their separate sides of the aisle.
Rose knocks on the window of the projection booth. Avery looks up. Sam does not. Rose waves. Avery waves back and goes back to sweeping. Rose looks at Sam. She knocks on the window again. Sam does not look up. Blackout.

SCENE FOUR

Sam and Avery sit with their brooms on either side of the aisle. Avery has a neatly folded letter in his hand that he is about to read out loud.

SAM

Okay.
Ready.
Actually. Wait.

AVERY

What?

SAM

If I listen to this you have to do Ezekiel 25:17 for me once it's over.

AVERY

Uch. Fine.

SAM

Great. I'm ready.

AVERY

"Dear Mr. Saranac,
My name is Avery Sharpe and I am an employee at the North Brookfield Flick.
I recently learned of your plans to buy The Flick and turn it into the North Brookfield 'Venue.' I commend you on your keen business sense and your entrepreneurial . . ."
I'm still trying to figure out the right word to use. "Entrepreneurial . . ."

SAM

Embarkings? Entrepreneurial embarkings?

AVERY

That doesn't make sense.

SAM

Spirit?

AVERY

"I commend you on your keen business sense and your entrepreneurial spirit."

SAM

I like that.

AVERY

I don't know. I just want to be you know, nice / before I—

SAM

Sure. Sure.

AVERY

"I commend you on your etcetera etcetera. Steve Bosco also informed me and the rest of The Flick employees that you intend to keep us on if we so desire and that you—"

SAM

Wait: "if we so desire" sounds a little gay.

AVERY

What does that mean?

SAM

It sounds gay.
 (in a British accent)
"If we so desire."

AVERY

That's a British accent.
Do you mean it sounds British?

SAM

Same thing.

Pause.

AVERY

"—and that you also plan on replacing our thirty-five-millimeter Century projector with a digital projector. I understand you may have many good reasons behind this decision—fewer maintenance fees, simpler training for new projectionists, the unavoidable fact that many movies are now shot digitally, and, of course, the desire to keep working with companies like 20th Century Fox who starting in January will refuse to distribute any of their movies on thirty-five-millimeter film."

Pause.

AVERY

"However."

SAM

Ha-*ha*!

AVERY

"However. I urge you to think twice about this decision. You are the only theater in Worcester County, and one of only eight theaters in the entire state of Massachusetts, that still use a film projector. This is an honor, Mr. Saranac. You are carrying a torch and I strongly encourage you not to extinguish it."

SAM

Nice.

AVERY

"Movie aficionados like myself come to this theater because of your film projector. And as more and more movie theaters in the United States convert to digital projection I predict that the brave few that continue to use film will become highly valued. You see, Mr. Saranac, the word 'film' refers to celluloid. So if you say, 'Wanna see the new Spielberg film?' you are by definition saying, 'Wanna see the new Spielberg movie' *on celluloid*. By the way, people like Steven Spielberg have spoken out about this very issue and he is on the record as saying that he will continue to shoot on thirty-five-millimeter until they pry the camera out of his cold, dead hands."

SAM

Wait.
He said that?

AVERY

Well, not the cold, dead hands part. That's a / joke.

SAM

Too much. Take it out.

AVERY

Really?

SAM

Yeah. It just makes you sound crazy.

AVERY

Okay. "He will continue to shoot on thirty-five-millimeter" blahblahblah. "Because of people like Mr. Spielberg and many others who WILL continue to shoot on film, it's important that there still be a few remaining theaters that use film projectors. When you digitally project a movie that was shot on film, you are not actually showing that movie. You are not giving the audience what they paid for."

SAM

Nice. Powerful.

AVERY

"Film can express things that computers never will. Film is a series of photographs separated by split seconds of darkness. Film is light and shadow and it is the light and shadow that were there on the day you shot the film."

Pause.

AVERY

"Digital movies—I think the phrase digital film is an oxymoron—are actually just millions of tiny dots. These dots, or pixels, cannot express the variation in color and texture that film can. All the dots are exactly the same size and the same distance apart.

Mr. Saranac, projecting a thirty-five-millimeter film digitally is like looking at a postcard of the Mona Lisa instead of the Mona Lisa itself.
I urge you to keep our beloved Century projector and to take a stand against the digital takeover of American movies and movie theaters.
Sincerely,
Avery Newton Sharpe."

Pause.

 SAM

Middle name Newton.

 AVERY

Yup. Don't make fun of me.

 SAM

I would never.
My middle name is Gruber.

Pause.

 SAM

I think it's a good letter.

 AVERY

You do?

 SAM

I do. Something about it is really . . .

 AVERY

What.

SAM

I don't know. It's like something someone would write in a movie. I mean, like the hero of the movie. He'd like bring it to Washington and go like running down the corridor of the courthouse and like stop to kiss the love of his life and she'd say, like, you know, GO FOR IT, and then he'd run into the courtroom and read this letter in front of the judge.

AVERY

And what would the judge say?

SAM

You know.
"On this day of all other days . . ."
"We have learned . . ."
"I am humbled to admit that even in my old age I can . . ."
You know:
"This young man has taught us the true meaning of Christmas."

AVERY

Okay. Cool.

Pause.

AVERY

Did I convince *you?*

Pause.

SAM

Oh. Hm. Good question.

Pause.

SAM

You know, I guess I don't really care either way.

Blackout.

SCENE FIVE

The lights in the theater are completely different. It's as if all the bulbs have changed their wattage, or gone fluorescent, or switched location. Sam and Rose are sitting on different sides of the aisle. They are both wearing new uniforms. A yellow polo shirt instead of a maroon one, or vice versa. Now the words "The Venue" are stitched on their pockets.
Rose and Sam are waiting for something. After a silence:

SAM

He said I couldn't wear my Red Sox cap anymore.

ROSE

Seriously?

SAM

Uh-huh. And I was like, Paul, we live in Massachusetts. It isn't like a . . . like a controversial hat.

ROSE

And?

SAM

He didn't go for it.

After a silence:

SAM

So how are you?

ROSE

I'm okay.

Pause.

ROSE

My roommate left this like long passive-aggressive note on my
bedroom door this morning. It was like seven Post-Its long.
And she has this really annoying handwriting.
Anyway, whatever.

After a pause:

ROSE

How are *you*? I have no idea how you're / like—

SAM

I'm okay.

Pause.

ROSE

What's—what's new?

Pause.

SAM

Not much.

Pause.

SAM

I went on a date last night.

ROSE

Oh yeah?
With like—
Was it a first date?

SAM

It was a first date.

ROSE

Was it an internet date?

SAM

It was an internet date.

ROSE

And?

SAM

I liked her.
She was actually pretty cool.

Pause.

SAM

Tiler.
With an i.

<div align="center">ROSE</div>

Huh.

Pause.

<div align="center">ROSE</div>

What does she do?

<div align="center">SAM</div>

Well.
At the moment she is a barista—

<div align="center">ROSE</div>

Okay.

<div align="center">SAM</div>

—but she's also sort of a um part-time low-flying trapeze artist.

<div align="center">ROSE</div>

Oh wow.

Pause.

<div align="center">ROSE</div>

So she must have like a really great body.

Pause.

<div align="center">ROSE</div>

If she's like a trapeze artist.

Sam sighs. After a short pause:

<div align="center">SAM</div>

Why do you have to be so crude?

ROSE

What do / you—

SAM

Like, you're always like, you know, talking about you know, oh, yeah, he had a huge cock, or like, or like, she's like she's like—wow she must have a nice pussy or something.

ROSE

I have never said anything about anyone having a nice pussy in front of you.

SAM

You know. You know what I mean.

ROSE

You must be thinking about Tiler and her nice pussy because I never said / anything about—

SAM

I have been on one date with Tiler!
I have never even kissed Tiler!

Pause.

ROSE

Whatever.

SAM

Look, you . . . you've made it clear that you're not interested. So I don't understand why you can't have a little like you know pity on me and / like—

ROSE

You wouldn't look at me!

SAM

What does—what does—why does—wait—what does that have to do with—why are you—that is like / completely—

ROSE

You didn't even give me a / chance to—

SAM

You said that I didn't know you! And that . . . that you were nothing like the person I thought you were! So—

ROSE

So that's true!

Pause.

SAM

So—

ROSE

So that's a fact!

Pause.

ROSE

But like . . . that doesn't mean you have to run out and start like internet-dating and like forget all about me.
Like oh yeah, you must be really in love with someone if you like do that.

SAM

So—so—so—so what are you—
Do you like want to go out on a date or something?

Pause.

ROSE

No!

SAM

SO WHAT ARE YOU SAYING?!

Pause.

ROSE

I'm just saying that I was right. That it was like a . . . that it was like a big performance. That's all.

Pause.

SAM

I can't believe this.
I can't believe this.
This doesn't make any sense.

Pause.

SAM

You want me to / like—

ROSE

Just like GET TO KNOW ME!

SAM

I can't get to know you if you keep acting like a . . . like a . . . like a . . . like a—

ROSE

What? Say it.
Say it.

SAM

Never mind.

ROSE

You think I'm like a total bitch.

Pause.

ROSE

Right?!

He doesn't respond.

ROSE

You like totally hate me now.
So just say it!

Avery walks in, also in a new uniform. He looks deeply shaken. They fall silent.

AVERY

Hey.

ROSE

How'd it go?

AVERY

Uh—
Well—

SAM

He told *me* I couldn't wear my Red Sox cap anymore.

AVERY

Oh. That sucks.

ROSE

He's got a weird face, right?

Pause.

SAM

Did he say anything about your letter?

AVERY

He figured out Dinner Money.

ROSE

Wait, what?

AVERY

He figured it out.
He looked at the books and looked at the receipts and like—
apparently there was like *too* much money in the register from
like last month and that's like a sign that people are stealing
and then he found the shoebox with the stubs underneath /
the—

SAM

Fuck.
Fuck!

ROSE

Wait, why was he looking at the books from last month? What
does he care? He has like a whole new system and a credit card
machine! We're not gonna steal from *him*!

AVERY

I guess he like . . . he wanted to make sure we were good
employees, or / like—

SAM

So—so what was . . .

AVERY

He was mad.

Pause.

ROSE

Well, yeah. But what / was—

AVERY

And he thinks it's me.

Pause.

AVERY

I mean, he thinks it's all me.

Pause.

ROSE

Because of your letter?

AVERY

There was a note for Sam in the box. In my handwriting.
 (to Sam)
From the weekend you were gone.
I guess he recognized my handwriting?
I also think he . . .

Pause.

ROSE

So what did you . . .

<center>AVERY</center>

I mean, I didn't rat you guys out.

Rose and Sam both try not to show that they are relieved.

<center>SAM</center>

Well.
Okay.
So we just need to uh. To uh.
To uh—

<center>AVERY</center>

Well, I was thinking that you guys could go to him and like fess up to your side of it too and like tell him that you were the ones who told me to do it in the first place and / then like—

<center>ROSE</center>

Wait.
What?

<center>AVERY</center>

—and then maybe he won't / like—

<center>ROSE</center>

Waitwaitwaitwaitwait.
Hold on hold on hold on.
Let's all like stop and take a deep breath.
 (*pause*)
Why should we tell him we were the ones who told you to do it in the first place?

Pause.

ROSE

Which by the way is kind of a um whatsitcalled revised way of looking at it. If I recall correctly you were pretty happy to take fifteen bucks from us every night.

AVERY

Because if we say that all of us were doing it and it was like an employee tradition like you said and that everyone did it maybe he'll understand and like . . . not fire me.

ROSE

He'll fire all of us.

AVERY

I mean, or he'll like let it go.

Pause.

ROSE

Whoa.
Okay.
That's really intense.
That's a really intense thing to ask of . . . to ask us to do.

AVERY

. . . I didn't tell on you.

ROSE

Yeah, well, that would have been like *evil*.

Sam is silent.

ROSE

Sam?

SAM

Uh-huh.

ROSE

Do you have anything to say about this?

He shakes his head no, averting his eyes.

ROSE

No?

He shakes his head no again. Both Avery and Rose look at him, betrayed.

ROSE

Okay. Great.

A horrible, horrible silence.

ROSE
 (politely, to Avery)
I'm just um . . .
How much money does your dad make?

AVERY

Excuse me?

ROSE

I'm just curious. Your dad teaches semantics at Clark, right?

AVERY

Yeah. Semi—
Yeah. I told you that.

ROSE

How much does he make?

AVERY

That's none of your business.

ROSE

And you have a free ride, right?

Pause.

AVERY

I don't see how—

ROSE

Because I still have like twenty thousand dollars in student loans to pay off and my mom is a secretary.
And I don't have a rich dad.

AVERY

My dad isn't rich.

ROSE

And Sam is thirty-five and he lives in a shitty attic above his crazy parents.

Sam winces but does not say anything. Pause.

ROSE

And this is our like—this isn't like a job we have *while* we go to college.
This is what we like—feed ourselves with.
 (pause)
So I just think that . . .

AVERY

Wow. Okay.

ROSE

I just think that you should think about that.

A long pause.

ROSE

It's just a like really really intense thing to do to ask some-
one who's super in debt and someone who didn't even *go* to /
college—

SAM

(quietly)
Okay, Rose—

ROSE

—to like give up their jobs to like defend you.

Pause.

ROSE

It just makes me feel like you don't really get it.

Pause. Avery just stands there.

ROSE

And I mean, I'm really sorry that Paul is blaming you.
That's really fucked up.

*Another pause. Avery takes off his glasses, polishes them on his shirt,
and puts them back on again.*
He puts his hands on his hips. He seems to be waiting for something.
Finally:

SAM

What did he say about the projector?

Pause.

AVERY

He's getting rid of it.
He's going digital.

Pause.

SAM

(small, hopeful)
So maybe you wouldn't have wanted to stay?

Pause.

SAM

(even more tiny and feeble)
I mean, maybe you would have wanted to quit anyway.
I remember you saying that.

Avery looks at Sam for a long time, then nods. Then he slowly walks up the aisle toward the door. Then he stops.

AVERY

Hey Sam.

Pause. Sam looks at him.

AVERY

You want me to do Ezekiel 25:17?

SAM

Huh?

AVERY

You want me to do Ezekiel 25:17 for Rose?

Pause.

SAM

Uh . . . maybe . . .
I'm not sure if now is the right / time to—

AVERY

EZEKIEL 25:17.
THE PATH OF THE RIGHTEOUS MAN IS BESET ON
ALL SIDES BY THE INEQUITIES OF THE SELFISH
AND THE TYRANNY OF EVIL MEN.
BLESSED IS HE WHO, IN THE NAME OF CHAR-
ITY AND GOOD WILL, SHEPHERDS THE WEAK
THROUGH THE VALLEY OF THE DARKNESS. FOR
HE IS TRULY HIS BROTHER'S KEEPER AND THE
FINDER OF LOST CHILDREN.
AND I WILL STRIKE DOWN WITH GREAT VEN-
GEANCE AND FURIOUS ANGER THOSE WHO
ATTEMPT TO POISON AND DESTROY MY BROTH-
ERS. AND YOU WILL KNOW I AM THE LORD WHEN
I LAY MY VENGEANCE UPON YOU.

Pause. Avery speaks thoughtfully, sadly.

AVERY

. . . I been sayin' that shit for years.
And if you ever heard it, it meant your ass.
I never really questioned what it meant. I thought it was just
some cold-blooded shit to say to a motherfucker before you
popped a cap in his ass.
But I saw some shit this morning that made me think twice.
 (after a pause)
Now I'm thinking: it could mean you're the evil man. And I'm
the righteous man. And Mr. Nine-Millimeter here . . . he's the

shepherd protecting my righteous ass in the valley of darkness.
Or it could be, you're the righteous man and I'm the shepherd
and it's the world that's evil and selfish. I'd like that.
But that shit ain't the truth.
The truth is, you're the weak.
And I'm the tyranny of evil men.
But I'm tryin', Ringo.
I'm tryin' real hard to be the shepherd.

He is looking at Sam. Sam looks like he might cry. After a silence:

ROSE

. . . That was awesome.

Avery leaves.
Blackout.

SCENE SIX

The theater is dark and empty. The film projector is on. We hear it whirring. It flashes green, then white, then it goes off.

We see Rose and Sam enter the projection booth and turn on the lights. They are wearing their new uniforms. They are talking and moving around in the little lit-up window. They seem to be getting along. Maybe at one point Rose laughs and hits Sam on the arm. The theater is still dark.

Then we watch Sam and Rose slowly and methodically disassemble the film projector. They remove the reels and then, piece by piece, they remove the film projector from the window and put it on the floor of the projection booth. This might take a little while.

Then we watch them install the new digital projector. It doesn't take very long. They turn it on for a second to try it out. It emits a glowing square of white light and then begins to project images. It is on for a while, projecting images we can't see. Sam and Rose leave the booth. Then the projector goes to green, then white, then darkness. The lights in the movie theater flicker on, and after about five seconds:

SCENE SEVEN

The door at the back of the movie theater is thrown open.
Sam peeks his head in, looks around, then closes the door.
A second later, the door opens again and Sam drags in a large trash
can that he uses to keep the door propped open. Then he exits again
and reenters carrying a large push broom and dust pan.
Skylar follows him, carrying a broom and dust pan of his own.

SAM

So this is the walkthrough.

SKYLAR

Cool.

SAM

Pretty easy.

Sam goes over to his side of the aisle and starts sweeping. Skylar goes over to the other side of the aisle and starts sweeping. He's a good sweeper. He accidentally kicks a plastic Coke bottle and sends it rolling down the aisle. Then he chases after it, picks it up, and runs it back to the trash can next to the door. He is speedy. He sweeps faster than Sam. Sam watches him, impressed.

SAM

Have you worked at a movie theater before?

SKYLAR

Yeah. At Cinema World.
In Leominster.

SAM

Oh yeah. I know that one.

After a pause:

SAM

(*trying to make a joke*)
So you're used to the oversized polo shirt.

SKYLAR

Uh-huh.

They clean in silence for a while.

SAM

Did Paul or someone else go over the soda machines with you?

SKYLAR

Yeah. Paul did.
I think I got it.

SAM

Cool.
Cool.
 (*pause*)
Did he talk to you about how to clean the butter dispenser?

SKYLAR

Uh—

SAM

I do Windex and then I use the almond hand soap in the bath-room.

SKYLAR

Oh. Okay.
At my old job we just Windexed and then rinsed it off.

After a short pause:

SAM

Yeah.
I would try the almond hand soap too.

SKYLAR

Okay. Cool.

They keep cleaning.

SAM

What else.
What else.

After a pause:

SAM

For some reason people don't see the garbage can underneath the island . . . the butter and straws island . . . it's just . . . it's like constructed badly. It didn't used to—
Anyway, people think there's no garbage so they like leave all their straw wrappers and stuff on the island so I try to you know swing by there a few times before the movie starts and like brush all the wrappers and like popcorn kernels or whatever into the trash.

SKYLAR

Okay.

Pause.

SAM

There used to be three of us working at a time including the projectionist but now it's just two. One of us goes up and presses play when it's time for the movie to start. It's pretty easy.

SKYLAR

Cool.

SAM

If you're working at the same time as Rose you should probably let her do it.

SKYLAR

Okay.

Pause.

SAM

We used to . . . Rose used to like splice together the previews.

SKYLAR

Wow.

SAM

Yeah.

They sweep for a while. About twenty seconds of sweeping pass. Skylar finishes sweeping before Sam. He waits patiently in front of the first row. He looks out at the movie screen. After a little while, he walks up to the movie screen, at the lip of the stage, and then reaches out and lightly touches the movie screen. Sam notices immediately.

SAM

Whoa. What are you doing?

SKYLAR

(backing away)
Oh. Sorry.

SAM

No. Just—why did you do that?

SKYLAR

. . . I don't know.
Sorry.

After a pause:

SKYLAR

I always have this urge to like . . .
I always just kind of want to touch it.
Don't you?

<center>SAM</center>

(disturbed)
Uh . . . no.

<center>SKYLAR</center>

Oh. Okay. Sorry.

Skylar waits for Sam to finish sweeping. Sam finishes, somewhat hurriedly. They head up the aisle. They dump their dust pans in the trash can. They exit. The door slams shut behind them. Blackout.

SCENE EIGHT

Avery, in street clothes, is standing in the middle of the aisle, waiting. The door to the theater is propped open. Sam, also in street clothes, is up in the projection booth moving around.

AVERY

(calling out)
Are you sure he's not here?

Sam doesn't hear him. He leaves the booth and a few seconds later he comes down into the hallway with a strange-looking piece of metal equipment. He heaves it onto the floor.

AVERY

Are you sure he isn't gonna like come in all of a sudden?

SAM

Yeah, yeah. He's away for the weekend.
Trust me.

Sam disappears again. A few seconds later we see him in the booth, moving around. He leaves and then comes down with another piece of equipment. He puts it down in the hallway next to the first piece.

AVERY

He's not gonna notice it's gone?

SAM

He tried to sell it on eBay and nobody wanted it. So he told me to donate it as scrap metal.
I've been saving it for you.

Sam disappears again. Avery waits. He looks at the movie screen for a little while. Then Avery walks into the hallway, picks up the first piece of equipment, and leaves. A few seconds later, Sam comes down again with another piece of equipment. It's becoming clear that he is bringing down pieces of the disassembled film projector. He looks around for Avery, confused. A few seconds later, Avery returns.

SAM

Where'd you go?

AVERY

My dad is waiting out front. In his car.

SAM

Oh. Okay.

Sam disappears again. Avery picks up two pieces and disappears again. Sam comes down again with the last piece of the projector. A few seconds later, Avery returns, wiping his hands on his pants.

SAM

This is it.

AVERY

Okay. Cool.

They stand there for a second.

SAM

Oh. Wait.

Sam runs back up to the projection booth. We see him grab two octagonal tins. He comes back down with them.

SAM

Some of Steve's old reels. He took most of the good ones. But there are a couple left.

AVERY

Oh. Okay.

Sam puts each one down on the floor, reading its label out loud while he does this.

SAM

Crouching Tiger Hidden Dragon . . .
Rugrats in Paris . . .

He runs back up to the booth, then comes back down with two more tins, heaving them down on the ground.

SAM

Star Trek Insurrection . . .
. . . and Honey I Shrunk the Kids.
That's actually a pretty good find.
You want them?
We were just gonna throw these out too.

AVERY

Um.
Yeah. Sure.
Hold on.

He picks up two of them, leaves the theater, and then returns thirty seconds later. He picks up the last two containers and holds them, one in each hand. They are heavy.

SAM

So what are you gonna do with the projector?

AVERY

I don't know. Start some kind of underground basement cinema movement?

Sam laughs.

AVERY

I'm sort of serious.

SAM

Oh. Okay. Cool.

AVERY

Maybe when I go back to Clark in the fall I'll form a thirty-five-millimeter film society. I don't know.
Own my own theater some day.

SAM

Awesome.

A long pause.

SAM

Look.
I uh—

Another pause. Maybe Avery has to put down a tin because it's too heavy.

SAM

I'm sorry, Avery.

A pause.

AVERY

No. I mean. Whatever. It was good for me.

A pause.

AVERY

I had some kind of stupid idea that we were friends. / And then—

SAM

(in pain)
Oh god.

AVERY

Let me finish. And then it became like very clear that we . . .
Look, everything that's . . . everything that's like ever happened to me has disappointed me. The world keeps . . .
So clearly I'm like . . . clearly I'm like putting too much faith in stuff.

Pause.

AVERY

I mean, I think the truth is that you can't trust anybody.

SAM

That's not true.

AVERY

No, I don't mean that in a bad way. Not like everyone is untrustworthy or something. Just like, don't expect anything. Don't expect things to turn out well in the end.

SAM

Uh . . . I don't know if I agree with that worldview.

AVERY

Look, realizing that has helped me.
It's actually made me feel okay for the first time in a while.
I like let go of . . .

Pause.

AVERY

I'm not saying I want to be friends with you or anything. I don't.
 (*after a short pause*)
And you know, we were never really friends in the first place.
I let Rose show me how to use the projector.
Every man for himself, you know?

SAM

Jesus, Avery.

AVERY

I think that's the way it goes.
 (*unable to help himself*)
And the truth is, one day I'll come back to visit Massachusetts and you'll still be here sweeping up popcorn. Working for some bigot from Nashua. And I'll be like . . . I'll be living in Paris or something. So . . . you know.

Pause.

AVERY

Thanks for thinking of me. And for saving the projector. And the film.

Pause. Avery bends down and picks up the last tin.

AVERY

Do you remember the end of the movie Manhattan?

SAM

Uh—

AVERY

Woody Allen like realizes he's still in love with Mariel Hemingway and he like runs down the street and finds her in her doorway and she's getting ready to go to London and she's brushing her hair and he's like stay here with me or whatever, and she's like, no, I'm leaving, and he's like, but what's gonna happen? and she's like: "You gotta have a little faith in people" and the music swells up?

SAM

Oh.
Yeah.

AVERY

This is like the opposite of that ending.

Avery turns to go and starts walking up the aisle toward the door.

SAM

Look. Avery. Just—before you go. I know my life might seem kind of depressing to you, and you know, in a lot of ways it is. But there's some good stuff in it.

Maybe I never told you about it, but there's some really good stuff in my life.

Pause.

SAM

And sometimes the people you fall in love with fall in love with you back.

Pause.

SAM

Sometimes they don't. But sometimes they do. And it's awesome.

Pause.

SAM

And I feel like once that happens to / you—

AVERY

Okay. Thanks for the advice, Sam.

Avery walks toward the door. As he walks out:

SAM

Macaulay Culkin to Michael Caine.

Avery stops and shakes his head no.

SAM

Macaulay Culkin to Michael Caine.

AVERY

See ya, Sam.

Avery walks out the door. It closes behind him. Sam stands in the aisle of the movie theater, his hands stuffed into the pockets of his pants. He stares at the door, waiting. A very very long amount of time passes.
Maybe a minute and a half.
Sam stands there patiently.
Suddenly Avery comes back in through the door, unsmiling.

AVERY

Macaulay Culkin to Mandy Moore in Saved.

Sam bursts into a beatific grin.

AVERY

Mandy Moore to Robin Williams in License to Wed.
Robin Williams to Jude Law in A.I.

SAM

Robin Williams was / in—?

AVERY

I think it was uncredited.
He was like the voice of the computer robot guy.
Trust me.

SAM

Okay.

AVERY

. . . Jude Law to Michael Caine in Sleuth.

They look at each other. Avery is still unsmiling.

AVERY

Easy.

And with that, Avery leaves.
Sam sits down in one of the seats, smiling to himself.
One of the orchestral themes from Jules and Jim *("Vacances" by*
Georges Delerue) starts playing, underscoring Sam's movements.
Sam puts his feet up on the seat in front of him and looks up at the
ceiling of the movie theater for a while. Then he gets up, still smiling,
and walks up the aisle. Right before he exits, he flicks off the lights.
The theater is plunged into darkness. The sound of the door closing.
The music swells.
Blackout.

END OF PLAY

ANNIE BAKER's other full-length plays include *Circle Mirror Transformation* (Playwrights Horizons, Obie Award for Best New American Play, Drama Desk nomination for Best Play), *The Aliens* (Rattlestick Playwrights Theater, Obie Award for Best New American Play), *Body Awareness* (Atlantic Theater Company, Drama Desk and Outer Critics Circle nominations for Best Play/Emerging Playwright), and an adaptation of Chekhov's *Uncle Vanya* (Soho Rep, Drama Desk nomination for Best Revival), for which she also designed the costumes. Her plays have been produced at more than a hundred theaters throughout the U.S. and in more than a dozen countries. Recent honors include a Guggenheim Fellowship, the Steinberg Playwright Award, a New York Drama Critics Circle Award, a Lilly Award and the Time Warner Storytelling Fellowship. She is a resident playwright at the Signature Theatre.